A Lifetime in
GATLINBURG

A Lifetime in
GATLINBURG

MARTHA COLE WHALEY
REMEMBERS

MARIE MADDOX

THE
History
PRESS

Published by The History Press
Charleston, SC 29403
www.historypress.net

Back cover: A 1940s postcard of the Hotel Greystone, Gatlinburg's fourth hotel, built in 1942 by Dick and Martha Whaley. *Courtesy of Robin Whaley Andrews.*

First published 2014

Manufactured in the United States

ISBN 978.1.62619.684.1

Library of Congress CIP data applied for.

This book is dedicated

to Nina Maddox, my Sunday School teacher when I was thirteen and later my mother-in-law, who made me believe that I could do anything I set my mind to and, for thirty years, loved me and supported me in everything I did,

to Glenn Bogart, my middle school principal, muse and mentor, who, for the next twenty years, challenged me, believed in me and encouraged me,

and to Shelley, my daughter and best friend, who, no matter where I go or what I do, whether I succeed or fail, whether we agree or disagree, loves me unconditionally.

Contents

Preface

S he came late into my life, I guess you might say. She was one hundred, and I was sixty. Our meeting wasn't really planned. I agreed to have breakfast with a mutual friend, Karen Houck, who breakfasts every Saturday morning with a group of her friends from First Baptist Church of Gatlinburg. They eat at the Little House of Pancakes, one of the twenty-two pancake houses in Sevier County. (In fact, some of them gather there every day for lunch. Little House gives a local discount and serves good food, reason enough to eat there at least once a week.) Karen said she thought I would enjoy meeting these folks, particularly Martha Cole Whaley.

I had my doubts. I'm not a morning person, and I'm not big on breakfast, but the appointed time was 10:30 a.m.—not too early. I decided to give it a try because I am always looking for something new or different to do, and I love meeting new people. There were just four of us at that first meeting: Karen, Martha Whaley, Frances Mynatt (Martha's friend of more than thirty years) and me. And that's where it all began.

Though I don't want to sound hokey, I will say that was a life-changing day for me. Without any pretense or affectation, Martha is simply an inspiration to everyone who knows her. She doesn't spout platitudes or offer advice. She isn't haughty or egocentric. She isn't officious or eccentric. She is bright, sincere and witty; spunky, generous and kind. She has a mind like the proverbial steel trap. Whenever we can't remember a name, a relation or a place, we just turn to Martha, who immediately fills in the blanks.

Our little group of four has grown to ten or twelve most Saturdays. At this writing, Martha is 103 years old and still going strong. We all want to enjoy her company as often as possible for as long as possible.

Many of you will never have the good fortune of meeting her, so I persuaded her to recount for me memories from over ten decades. She knows so much about this part of Tennessee: the beginnings of the Great Smoky Mountains National Park; the first settlement school, Pi Beta Phi Elementary; the growth of the tourism industry; and the incorporation of the town and its history. One friend described her as a "great national resource." That made me smile; I think I would call her a "great natural resource."

But in addition to her wealth of regional history, I want you to know her as a person, so I have included her stories and reminiscences about her family, education, marriage, faith and friends. I also have described Martha the cook, the craftsperson and the sports devotee. I wanted to preserve all the wonderful history of our area stored in her brain, but I also hope you will laugh, love and be inspired as you get to know Martha. It is my hope that I have captured her spirit, even as she has captured my heart.

Acknowledgements

I feel like it has taken a small army to create a small book. I only hope that I won't overlook any of you who have soldiered on my behalf. My profound thanks

to Sara Collins, Frances Mynatt, John and Karen Daves, Pat and Russ Brien and Genie Brabham, who all encouraged me to write Martha's stories—to preserve them for posterity.

to Pamela and John Billing, friends for decades, who helped me find a place to do my writing, which resulted in a call to Jane and Terry Jones, who let me use their lovely cabin in the Escondido Valley outside Taos, New Mexico, for three weeks to write what I fondly call the "Martha Book."

to my sister, Marcia Cronin, professional freelance copy editor, who gave hours of her time to read and edit the manuscript and who coached me through the process. As a result, I have a practically perfect book, and I have learned to create an em dash.

to Barry Rhodes, the first reader following the editing, who said, "I couldn't put it down," which made me believe I had done something good.

to Vern Hippensteal, noted watercolor artist of the Smokies, who graciously and generously agreed to do a sketch of Martha for the book as a surprise for her.

to Martha's friends and family members, who wrote testimonials to introduce the chapters and whose names appear throughout the book.

to Robin Whaley Andrews, who has done a yeoman's share of the work helping me track down photos, getting people to write testimonials and answering myriad questions.

to Renee Coghlan, secretary at the First Baptist Church, Gatlinburg, who has been my "Girl Friday," helping me with whatever, whenever.

to all who contributed photographs—Marti and Richard Renfro, Robin Whaley Andrews, Genie Brabham, Sara Collins, Jack Miller Sr., Jody Cole Allen and Martha herself.

to Michael Aday, librarian and archivist at the Great Smoky Mountains National Park Archives, and Karen McDonald at the Anna Porter Library, who helped me find important historical photos.

to Will Lapides, who professionally scanned photos and scanned some more.

to Martha, who not only recounted her stories to me but also allowed me to tell her stories in her own voice. I pray that you will feel her presence and hear her laughter as you read these pages.

to Lisa Oakley, who suggested that I submit the manuscript to The History Press.

to Kirsten Schofield, commissioning editor at The History Press, who immediately accepted the manuscript and moved quickly to get it published because she understood how important it was to me that Martha get to see the finished product.

to God, who gave me the wisdom to know that this was something I was meant to do and to realize that it would be the book I have wanted to write for decades—a book about something important.

I am grateful and humbled by your love and support and by your enthusiasm for this project.

Author's Prologue

When I asked Martha about writing a book, she quickly said, "I don't like to write. My sister-in-law gave me a pad of paper and a pencil and asked me to write down stories as they occurred to me. Well, that pad of paper is still sitting there—blank."

With encouragement from her friends, all of whom are at least twenty-five years younger than Martha, I brought up the subject again. This time, I told her I would write, if she would tell her stories to me.

"If you ask me questions, I'll talk. I hate to write," Martha said.

"Well, I love to write, and I am the queen of questions. I think we are a match made in heaven," I replied. "I have friends who say I am just plain nosy. Of course, I am a bit offended by that. I just like to know as much about people as they are willing to share."

And so we began on a summer afternoon in early June, as soon as my teaching responsibilities ended for the year. I teach English and Latin, hence the interest in storytelling and writing.

We agreed to meet two or three times a week for a month and see where that took us. I can tell you that it took me to some of the happiest, most gratifying days of my life. Each meeting flew by, and each interview stirred more questions in my mind and more memories in hers.

But I also realized that the story needed to be told in first person, in Martha's voice. So, with her permission, she will speak to you through me. I hope you will enjoy "hearing" her stories as much as I did. I

feel honored to have been allowed to spend hours sitting with Martha to gather these stories for posterity.

Note that there are italicized pages before the beginnings of some chapters. These represent my additions to the narrative, as well as comments by some of Martha's friends and family.

Though I taped her interviews to capture her precise words, I can't transfer to paper the wonderful timbre and grit of her voice, which envelopes you with gentleness and warmth as soon as she begins to speak. You can almost sense it just by looking at the photographs of her. She is the consummate storyteller and quintessential mother, grandmother and great-grandmother.

When you finish reading, I hope you will number yourself among the thousands of people who know and love Martha.

Martha's Prologue

I suppose that I inadvertently am a natural resource. I am certainly not a historian. I haven't penned any of the town's one-hundred-year history; I have just lived it. And thanks to the good Lord, I still have a sharp mind. I told someone recently, "I can't hear. I can't see. I can't taste as well as I used to, and I don't smell very good either." We both laughed. "Well, that didn't come out like I meant for it to, but you know what I mean." But my mind is still good, and that is a real blessing.

So when Marie asked me to recall stories from the past ten decades of my life, that wasn't a problem. And the more questions she asked, the more stories I remembered—things I haven't thought about in lots of years. It's been a walk down memory lane for me.

Recalling these stories means that I have mentioned a lot of local names—some living, some not. I haven't told any stories that cast aspersions on anyone. So I hope all my readers will enjoy my recollections. And if you find yourself or family members in a story, know that you are there because you were an important part of my personal history.

I never realized that I would have to live to be 103 to become famous. Just this summer, I was interviewed for a newspaper article and did a segment for a local Christian television station. And now a book. What's next, I wonder? Dolly Parton better watch out; I'm moving up in the ratings.

I am sometimes asked how far back I can remember. I can remember back to when I started kindergarten. I was four. That seemed like a good place to start with Martha. Even though I know she has a great memory, I wondered if she would be able to remember back as far as I can since she is so much older. Likely, she might not; that seemed a logical assumption. Was I in for a surprise?

On a warm summer afternoon in June, I arranged our first meeting at Martha's condominium in Gatlinburg. I rang the doorbell and waited for her to answer. I had spent considerable time planning how I wanted to start my interviewing. I even sent Martha a letter outlining some things I wanted her to be thinking about, including her earliest memories. As I waited for her to come to the door, I wondered if things would go as I had planned.

I admired a beautiful red tuberous begonia resplendent in its birdcage-shaped black wrought-iron planter that hung just to the right of the front door. I touched it to be certain it was real. I would soon learn—that was the first of many examples of Martha's "green thumb" and her love of flowers.

The door opened, and with that warm southern hospitality so characteristic of Martha, she welcomed me in. Her home was welcoming, too. It was homey and comfortable, clean and orderly and beautifully appointed with family photos, handcrafts and lovely pieces from her world travels.

She claims it is too dark because when it was built in the 1980s, no one put in overhead light fixtures. "If I ever have another home, it will have overhead lights," she remarked as she turned on a large table lamp beside her favorite chair, a recliner that sits at the end of her sofa. It faces her flat-screen TV and, beyond it, her sun porch with its panoramic view of her dear Smoky Mountains cloaked in spring green and punctuated in the foreground with mountain laurel still in bloom. "I just love these mountains in all their glory. The picture changes with the season, but my mountains are constant," Martha sighed as she settled on the sofa and I on the loveseat. Seated there, we both had a view of her mountains and could comfortably talk.

So the story begins...

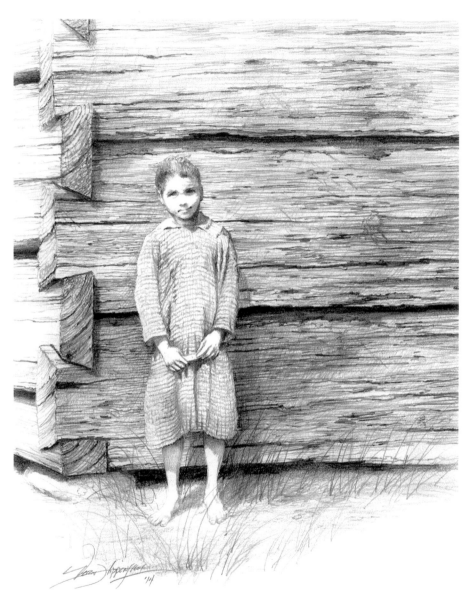

Noted local watercolor artist Vern Hippensteal's rendering of the young Martha Cole standing at the end of her granny's cabin. *Courtesy of Vern Hippensteal.*

Chapter 1

Mom, Dad, Granny and
My Childhood Home

I was born in our family home on April 1, 1910. I always thought I was delivered by a midwife whom everyone called Aunt Nancy. She delivered all my eight brothers and sisters—actually ten; two died. No one had a birth certificate in those days. I never had reason to think any differently.

Years later, after I was married in 1931, I asked a lawyer friend to get my birth certificate from Nashville. When it arrived, I discovered that I had been delivered by Dr. B.B. Montgomery. It still makes me chuckle to think about Doc Montgomery. He had about twelve children. I go to church with his grandson Bruce at First Baptist today. Old Doc used to say all he had to do was set his shoes under his wife's bed and she'd be pregnant.

I don't know why or how I happened to be the only one of us nine to be delivered by a doctor. And I don't know what time of day I was born. That's not on the birth certificate, and there is no one still living who would know that bit of information. Well, all that is a matter of public record.

What I know from memory, not from documentation, is that my earliest childhood recollection is of the birth of my little sister, Lucy, who arrived when I was three years old. She was the last of the children born to A.A. Cole and Mary Florence Sims Cole. A.A. stood for Albert Alexander, but folks just called my father Alex. We all called him Dad or Pap. We called my mother Mom, and Granny—my dad's mother, whose name was also Mary—was Granny to us all.

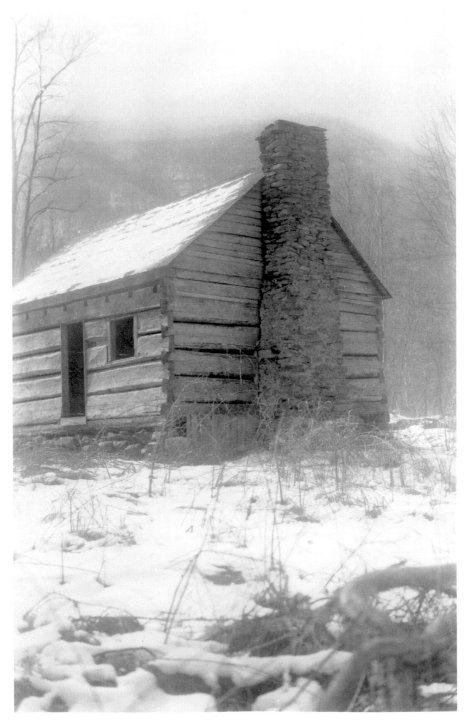

My granny's cabin. *Courtesy of Great Smoky Mountains National Park Archives.*

I have vivid memories of Granny, who was already a part of the household when I was born. I don't really know how long she had been there, and I don't know that I ever knew her husband's name. She had two children: my dad and a daughter who died in childbirth. So when her husband died, my dad didn't want her to live alone. He disassembled her cabin and rebuilt it right next to our house. Her door opened into our house.

Granny's people came from Scotland and Ireland. They, like so many Highlanders, chose to stay in this area because it reminded them of the highlands of home, so I am the third generation born right here in the Smoky Mountains.

Granny was like another mother to me. It didn't seem like mom and grandmother; I just had two moms. I never heard Mom and Granny quarrel. When Lucy was born, Granny said Mom and Dad doted on her. Granny said that wasn't equal, so she doted on me. I loved her just like my parents. I didn't know any difference in my feelings for them.

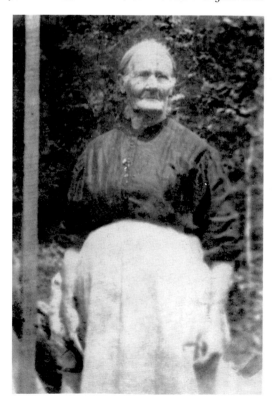

One year on Decoration Day, Lucy and I were supposed to make paper flowers to put on the graves of our loved ones, but we didn't know how. Granny gathered a purple bouquet and a pink bouquet of flowers for each of us to take to the cemetery.

Granny couldn't hear well at all. We had to scream at her. To this day, I think that's why all of us have such loud voices. We grew up screaming at Granny.

I don't have too many memories of Mom because she became too sick to take care of us or the house when I was just nine years old,

My granny, Mary Cole Newman, 1915. *Courtesy of Jody Cole Allen.*

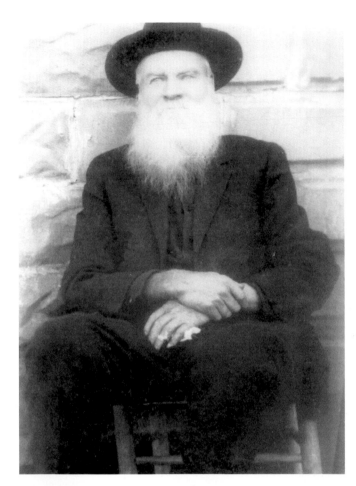

Left: Grandpa Vance Newman, who died before I was born. *Courtesy of Jody Cole Allen.*

Below: Granny on a walk in the woods with me (left), a tiny little cousin I don't recognize and Johnnie. *Courtesy of Martha and Richard Renfro.*

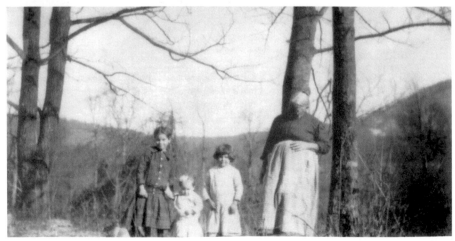

and she died when I was fifteen. I spent a lot of time at my sister Cora's house during those years when Mom was sick. I walked the three miles to her house, usually after church on Sundays. She lived across the mountain, over in an area known as Flea Branch.

I do remember that Mom was a little dried-up lady, never weighed over one hundred pounds. She was busy having children—eleven of us in twenty years, one about every two and a half years, except Lucy and I were three years apart.

I never heard her shout except one time when the first letter arrived from my oldest brother, Walt, when he was off fighting in France during World War I. She yelled, "Glory hallelujah!" (He returned safely after fifteen months of service in the war.)

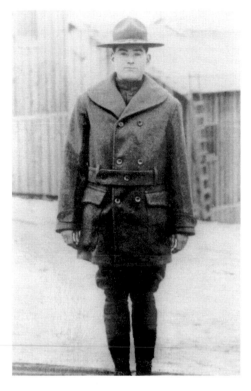

My big brother Walter in his World War I uniform. *Courtesy of Jody Cole Allen.*

Mom had an old treadle sewing machine that said "Household" on the treadle. I tried to learn to sew, but I could never get the rhythm of the treadle right. It would come up and hit the bottom of my foot. But my mom could sew anything.

She made the most beautiful buttonholes by hand. Women wore high-neck blouses with sixteen or eighteen tiny little buttons. Mom made all the buttonholes for friends and neighbors. Once she made buttonholes for a blouse for a neighbor named Lily, who later ran away with my mother's brother. Mom said, "If I had known that, I never would have made those buttonholes for her."

Dad tried to get help for Mom's sickness. He took her to different doctors in Knoxville, but no one could diagnose the problem. We suspect now that she had high blood pressure and died of a stroke. That runs in our family, but back then, they just said she was having a nervous breakdown and that there was nothing they could do.

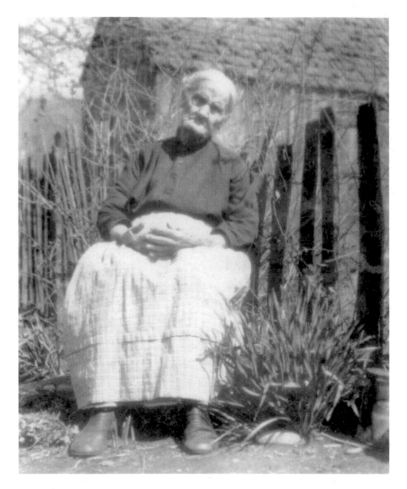

Granny getting on up in years, just "settin' a spell," as the old-timers say. *Courtesy of Jody Cole Allen.*

I took over cooking for the family when Mom couldn't do it anymore. I was just nine years old. Dad cooked sometimes. He made the best biscuits I've ever had, and his corn bread was good, too. He sometimes cooked wild meat—squirrel, ground hog and wild turkey. But his coffee—now that's another thing altogether. It was so strong it could swim an iron wedge. (That was one of Granny's sayings.) We had to put lots of milk in it to make it drinkable.

Mom died when she was fifty-five years old, but Granny, who was in her eighties, helped to fill the void. She lived to be ninety-three. Dad never dated or remarried.

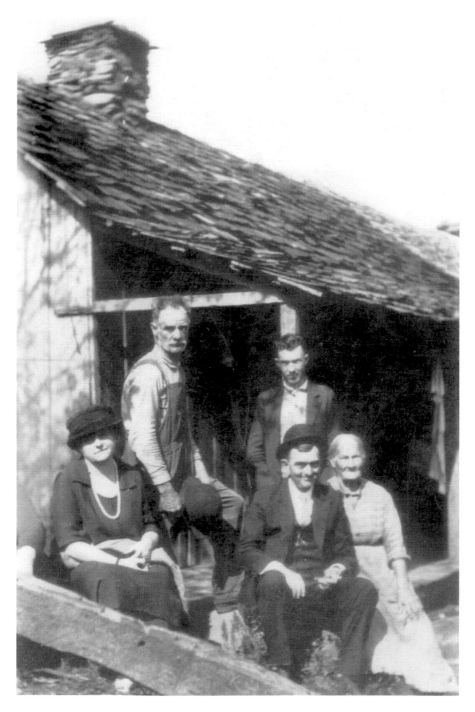

The Burtons, from Knoxville, paying Dad and Granny a social call at our homeplace.
Courtesy of Martha and Richard Renfro.

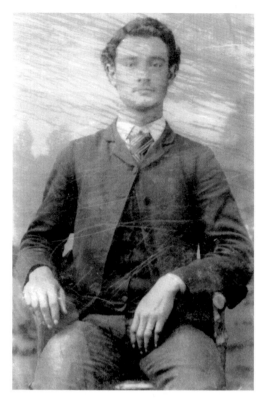

Dad was an avid reader; he always knew what was going on. He also had beautiful penmanship and a lot of common sense. He and Granny read the Bible faithfully. Mother could also read and write. They saw to it that we all went to school, through eighth grade anyway. None of us went to high school or college.

Dad was a tall, good-looking man. He always had a mustache—well, almost always. One day, he came home without it; none of us even recognized him.

He had helped to build the house we lived in long before I was born. It was a sturdy house that sat on forty acres of land in Sugarlands, an area of the Smoky Mountains that is now part of the Great Smoky Mountains National Park.

The house was about two miles beyond where the park headquarters is now located and was so named because of all the sugar maples that grew

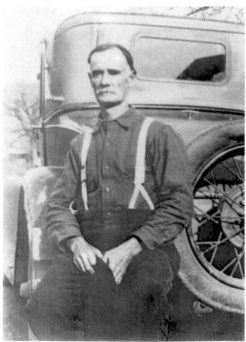

Top: An 1889 tintype of A.A. Cole when he was just nineteen years old. *Courtesy of Martha and Richard Renfro.*

Left: A great photo of Dad, but he never had a car, so I don't know whose car he is leaning on! *Martha Whaley's collection.*

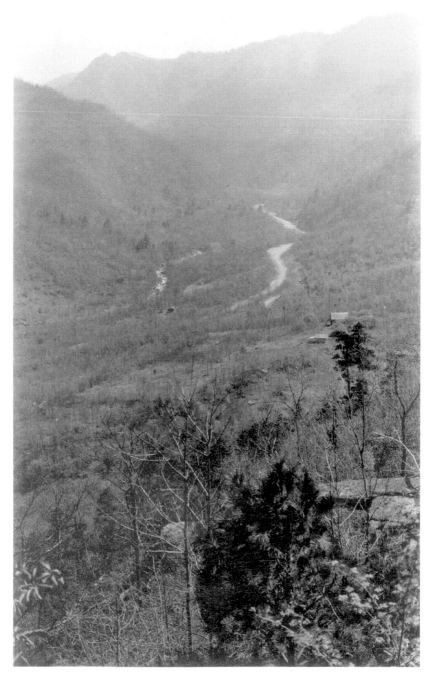

A view of Sugarlands Valley and the Little Pigeon River (1930), looking toward the Chimneys (extreme left). *Courtesy of Great Smoky Mountains National Park Archives.*

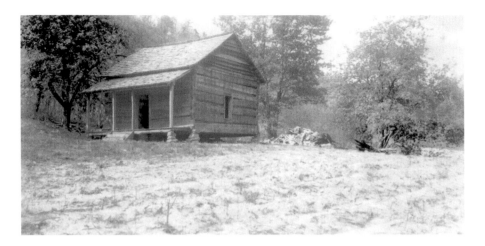

The homeplace, a house Dad built with his own hands—my home until I was fifteen, when I took off for the Burg. *Martha Whaley's collection.*

there. My older brothers, Syd and Julius, tapped the trees, and then Lucy and I made syrup, as did lots of folks. But when the park was formed, we weren't allowed to tap the trees anymore.

The house was only reroofed one time in all the years I lived there. I remember Dad splitting the wood with a froe to make the wooden shingles. It was a plank house, not log, with a big living room, a small kitchen, one big room with four beds for the children and another bedroom for Mom and Dad.

Our mattresses were covered with ticking. Most folks don't even know what ticking is. It was a heavy cotton fabric, like denim, off-white with about a half-inch-wide navy stripe. I don't know why it was called that, but everyone knew what you were talking about when you said "ticking." The mattresses were stuffed with oat or rye straw because it was lighter weight than feathers. Our pillows were stuffed with goose feathers.

We had an outhouse behind the house—way behind. (It wasn't until after I was married and moved into the Riverside Hotel that I had a flush toilet.) On Saturdays, we bathed behind the stove in a big washtub. If the weather was warm, we bathed in the river. We could swim in the river in Gatlinburg a whole month sooner than we could in Sugarlands because the temperature was that much warmer down there.

The house had a big, long porch across the front. On Sunday mornings, Dad would stand on the porch and sing in his wonderful deep, booming voice. I can still hear him singing, "There Is a Fountain Filled with Blood"

and "When the Roll Is Called Up Yonder, I'll Be There." Those were Granny's favorites. I also remember "Farther Along" and "Give Me That Old-Time Religion." I was always sure the folks down in town could hear him, too. If they were lucky, they did.

Dad was the Sunday School superintendent at the United Brethren Church near our house, the only church in Sugarlands. He prayed humble prayers on his knees. The church had no organ and no choir. Eventually, they got a pump organ. We all just sang the great old hymns as best we could.

One Friday, when I was twelve years old, Dad noticed that my high-top shoes had ripped in the back. He got up early the next morning and walked into Gatlinburg, about three miles each way, to get me a new pair of shoes for Sunday.

Dad was never idle. He was always looking for ways to make a good life for us. Before the park was formed, he used to guide tourists over the mountain, to Mount Le Conte and all around the area. He said they talked all the time. "If they'd quit talking, they could hike farther," he told us. He made a lot of friends with his hikes.

Little River Logging Company had started logging in the park before I was born. As soon as the train came from Townsend to Elkmont, the logging began. All the men in my family worked for the logging company at one time or another, including Dad, who set up a place at Elkmont where he could cook for the men.

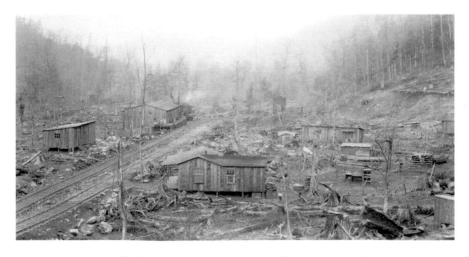

A logging camp near Gatlinburg. *Courtesy of Arrowmont School of Arts and Crafts.*

Construction begins on Highway 441 in the Sugarlands community (1928). *Courtesy of Great Smoky Mountains National Park Archives.*

Two of my brothers, Walt and Jess, and my sister Mag lived up there. The men felled the trees, put them on skidders and pulled them with horses down to the train that, in turn, took the timber to Townsend to be milled.

Later, when the first road was being built through the park, Dad set up a place to cook for the road builders right where the Chimneys picnic area is now. There wasn't any honest work that Dad wouldn't do to provide for his family.

Dad only hit me one time. He swatted my butt with his hat. I can't even remember what I did to earn that punishment, but it broke my heart because I had disappointed my dad.

We all honored our parents, and we honored our teachers. Parents told their children what to do, and they did it. Nowadays, children tell their parents what to do, and they generally do it. That's just not right.

If mortals could be saints, I am sure my dad would have been one. We had a good upbringing. Dad has certainly been the most influential person in my life.

Of the nine Cole children who grew to adulthood, Martha is the only one still living, but in this next chapter, she writes about her little sister Lucy, whose nickname was Johnnie, and Johnnie's special relationship with Francis Otto, who would one day become her husband. Well, that's me. I have known Martha seventy-eight years—longer than anyone else still living—so I wanted to recollect for readers how Martha became such an important part of my life.

I am now one hundred years old, and Johnnie has been gone since 2000. But I remember meeting Johnnie, Martha and Dick just as if it were yesterday. It was actually 1935. The Bureau of Roads had sent me from Chicago to Gatlinburg to make progress reports on the road being built to Newfound Gap. I arrived by bus, lugged my suitcase across the muddy road to the Riverside Hotel and asked for a room. The hotel was semi-closed for the winter, but Dick Whaley was in the office, Martha was running the kitchen and Johnnie was waitressing in the dining room. For me, it was love at first sight—not for her. I oogle-eyed Johnnie. She was beautiful. We were both twenty-two years old.

When the hotel opened on April 15, I had to move next door to the M&O Tea Room, where I had a room and ate lunch each day. The waitresses from the hotel gathered there to talk; it was there that I actually met Johnnie. I was looking for advancement in my work, which took me to Vicksburg and then to Washington, D.C., with the Department of Defense. I was in the navy from 1942 to 1946, and it was thoughts of Johnnie that kept me alive.

Every year, I went to Florida on vacations with friends, which enabled me to stop en route to see Johnnie in Gatlinburg. She was dating the local boys, but that did not stop me from proposing—every year for twelve years—as I passed through town. Then, in May 1947, the magic moment came: I got a letter that said, "Come on by, and we will go away." I couldn't get there fast enough. I stopped at Martha and Dick's, where Johnnie was living. That's the first time I really remember talking to Martha. She said, "Take good care of Johnnie."

We eloped. In Gainesville, Georgia, we stopped at a filling station, asked for a minister and got married at his house. We went on to St. Augustine, Florida, and then back to the D.C. area to live. Johnnie had lived with Martha and Dick for fifteen years. Martha missed her terribly and was hurt that she was gone.

Since we were both thirty-four years old, children were in our immediate future, and that worked to Martha's advantage. The arrival of Johnnie

Jo in 1949, Martha Jane (Martha's namesake) in 1951 and Richard Thomas in 1953 occasioned ten-day visits from Aunt Martha, who just had to come take care of her little sister. Her visits were a delight for all of us.

There was no keeping those two apart for very long. We visited Martha and Dick in Florida in the winters and vacationed in Gatlinburg three weeks every summer. Martha and Johnnie were so much alike. They were both gorgeous, good cooks and fun. That's the word I think best describes Martha–FUN. I loved Johnnie's roast pork and roast beef, but Martha's coconut pie was THE thing.

Now we are both centenarians. We still talk every Sunday; I visit when someone can drive me to Gatlinburg. She reminds me so much of Johnnie, and she is STILL fun.

Francis Otto

And Then There Were Nine

My five oldest brothers and sisters had already left home by the time I was born. That would be my brothers Walt and Jess; my sisters Nora and Cora, who came between Walt and Jess; and Mag, whose real name was Margaret, but no one called her that. She was Mag to us and Maggie to her friends. Syd and Julius still lived at home when I was born. And as I said, Lucy came last, and her birth is my first vivid memory of my childhood. A boy named Bruce died before I was born, and a girl named Carrie Mae died when I was not quite six months old, one of diphtheria and the other of croup. There wasn't really anything anyone knew to do about these childhood diseases.

I am not going to try to tell you all the stories I can remember about all my siblings, but I do want to tell you a little about each one. After all, it's our relationships, the people we love, the ones we care about and who care about us, who make our lives what they are, not how much money we make or how many possessions we have.

No one had cameras back then, but there was a traveling photographer who came through town periodically. I have the only existing family photo of Mom, Dad, Granny and us four younger children. It hangs on my wall now, and it is a real treasure. Everyone but Lucy is standing ramrod straight and not smiling, as was customary in photos of that period. However, Lucy has her chin tucked and her bottom lip poked way out in a big pout. I suspect, though no one ever said, that's because Dad, who is standing right behind her, had just

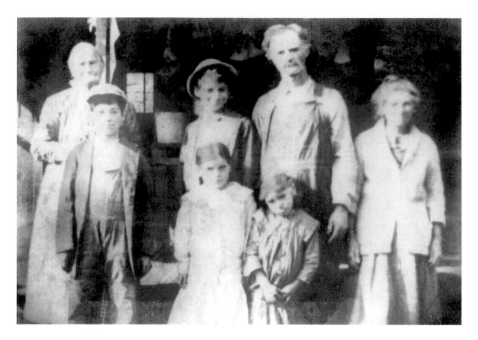

The family I grew up with. *From left to right, back row*: Granny, Syd, Dad and Mom. *Front row*: Julius, me and Johnnie. *Martha Whaley's collection.*

reached down and yanked her thumb out of her mouth. She was quite a thumb-sucker.

That may sound like I didn't like her, but I don't mean to give that impression at all. She was my favorite sibling, perhaps because she was the only sister near my age and the only one at home during my childhood. I always thought she was prettier than I. She had a head full of curly golden hair; mine was dark and not nearly as curly. And her hair stayed curly. I had to have three surgeries—gall bladder, appendectomy and C-section when I was forty-four. Each time, the anesthesia took my curls away. After the first two, the curl came back but less. After the third surgery, the curls were gone for good. Well, I digress.

I was always a tomboy; Lucy was not. But we still had great fun together. We loved to play hopscotch and hide-and-go-seek. We worked the garden together and took turns cooking when Mom became too sick to do that, and later on, we double-dated. We "came up together," as the old-timers say.

I should explain that Lucy was never called by her given name. My oldest brother, Walt, immediately nicknamed her Johnnie, and Johnnie

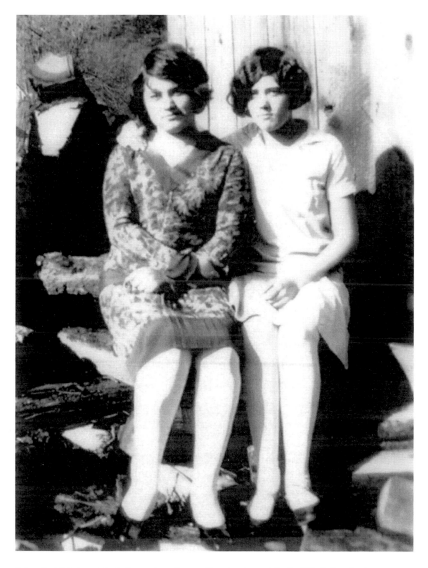

Johnnie (right) and I all dressed up in our Sunday best. *Martha Whaley's collection.*

she was until the day she died. Even her husband called her Johnnie. In fact, until Marie started writing this book, my closest friends didn't even know she wasn't really Johnnie. Maybe Walt got it from the expression "Johnny-come-lately," which had come into vogue in the late 1800s. Lucy/Johnnie certainly came late into *his* life, twenty years after he was born.

But Walt, too, doted on Johnnie. He bought her a new pair of shoes every year. When he was in World War I, he sent a letter with a note to tell Johnnie he was sorry he wouldn't be able to buy her shoes that year.

I think I would like Johnnie's love story to be a part of my story. She was working with me at the Riverside Hotel in Gatlinburg. We were both teenagers. The Bureau of Roads sent men to build a highway. One of those men was Francis Otto, a handsome man of German extraction who went by his last name. He was from Chicago and had graduated from Purdue University. Otto met Johnnie at the Riverside, and for him, it was love at first sight. For her, it was not.

Otto left to fight in the South Seas during World War II. He wrote to her the whole time he was gone. She never answered. When the war ended, he came back to find her. This time, she decided he was indeed the man for her. They married and moved to Arlington, Virginia, because Otto worked at the Pentagon. They had three children and were happily married for over fifty years. Every Sunday morning from the time they moved until Johnnie died thirteen years ago, at the age of eighty-three, Otto and Johnnie called at 8:30 a.m., before I left for church, to have our weekly visit.

Seven or eight years ago, Otto moved to Roanoke, Virginia, to be near his eldest daughter and her family. He has his own home next door to hers. When I asked him if he had met the neighbors, he said, "No, they're all old." Otto was ninety-three.

He had a little dog named Toot. Toot died right after Johnnie died, so his daughter got him another dog just like Toot. He named it Toot, too. Toot sleeps with him, and twice a day, he took Toot for a ride in the car. That has had to stop because at age ninety-nine, he had his driver's license revoked.

Otto still calls every Sunday, just like he and Johnnie had always done. Except sometimes it's Saturday because he's mixed up about the day. And it is quite the scene…he can't hear and I can't hear. We have an awful time on the phone.

Otto comes to visit when he can; his daughter Martha (Marti) and her husband, Richard Renfro, drive him here, and he always requests my coconut cream pie. He still cries when he talks about Johnnie. I think he feels close to her through me. She was very special to both of us.

Though Johnnie and I were especially close, each of my siblings has a special place in my heart.

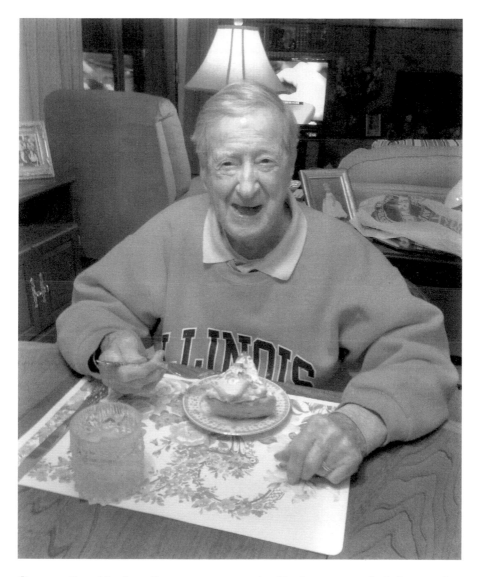

Otto sampling a big piece of my coconut cream pie—like there was any doubt he was going to love it. *Courtesy of Martha and Richard Renfro.*

Next above me on the ladder of children was Julius, who was not quite three when I was born. Julius and Syd were together a lot, too, because they were near in age and the only two boys at home.

Julius and I fought over the *Comfort*, a monthly magazine that Dad subscribed to. It was aimed at housewives and was full of ads, but it

37

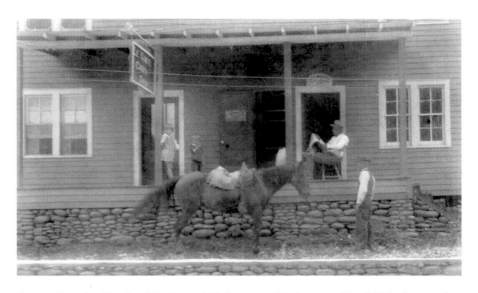

Our mail carrier, Crockett Maples, and his horse outside the post office (1926). *Courtesy of Great Smoky Mountains National Park Archives.*

had a serialized story that I loved. Clearly, there were things in it that Julius loved, too, or he just loved to aggravate his little sister. I was never sure which.

The magazine was delivered to the mailbox at the end of our road by Crockett Maples, the mailman, who came on horseback from Fighting Creek. He rode a four- or five-mile circuit every day to deliver the mail. (It was on the back of Crockett's boots that I saw the first zipper I had ever seen. He let me zip it up and down, an amazing invention.)

Though I could hardly contain my excitement, Julius always got to read the *Comfort* first because he was older.

Julius was a hard worker, a lay preacher and a good Christian man. He married Sara Trentham, and they had two children, Roy (who worked for years at Ace Hardware) and Hettie. In his later years, Julius worked for the National Park Service.

Syd, whose real name was Sydney Shepherd, fell out of an apple tree when he was just four years old, about two years before I was born. He was crippled for the rest of his life. He probably dislocated his hip, and had the doctors known to set it, he would have walked normally.

He never married. He lived with Dad until Dad died at the age of eighty-eight, in 1958, I think. Syd lived his last years in a nursing home

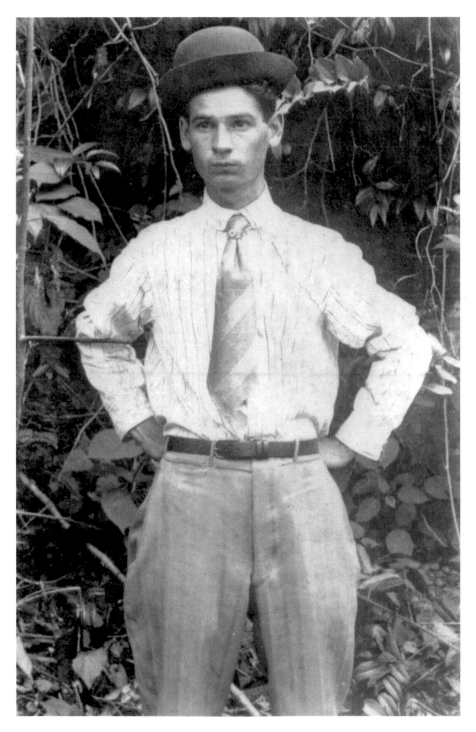

My brother Jess—quite a dapper fellow. *Courtesy of Jody Cole Allen.*

behind McNelly-Whaley Ford in Sevierville. He died of a stroke when he was eighty-three.

Next oldest was Mag. Mag was married to Hubert "Hugh" Parton. He drove a taxi. They lived up at Elkmont. They had five children—Pauline, Rex, Willa Belle, Faye and Agnes. Mag stayed at home with the children until they were raised. Then she worked as a pastry chef. Mag had her driver's license long before I did. When Otto and Johnnie moved to Arlington, Mag drove me up there to visit. Those were some grand trips.

Jess, was the next up the line. He was fourteen when I was born and out of the house before I really knew him. But he stayed in Sugarlands. He operated a small store where he sold flour, meal, salt, soda and other staples. Well, he sold them if folks had money. If they didn't, they paid him with a chicken or eggs. He also worked as a skidder foreman for the Little River Lumber Company.

Jess loved to joke, and folks loved that about him. He married Beedie Carr, and they had seven children: Maude, Myrtle and Gaston. Then nine years later, twins Charles and Elizabeth arrived. And guess what? Four years later, another set of twins, Jody and Judy, came along. Jess said that kids were cheaper by the dozen. But I guess he decided to settle for a baker's half dozen.

Then came Cora. Next to Johnnie, I was closest to Cora, even though she was eight years older than I and married by the time I was seven years old. Her husband was Fred Parton. Cora and Mag married brothers.

When Mom got so sick, I spent more and more time with Cora. She and her husband raised corn and chickens and me! They had five children, Ruby, Bill, Edna, Dixie and Henry. They were all still at home during my growing-up years. Ruby was my favorite; she and I were great friends.

Nora was two and a half years older than Cora. Nora was married to Walt Huskey. We started calling my brother "Brother Walt" to differentiate between brother-in-law Walt and brother Walt. Their oldest boy was a teenager when Nora had twins, Jay and Dee. Back then, a woman had to stay in bed eight or ten days after giving birth. I went to stay with her so that I could cook for the family; I was about thirteen or fourteen years old.

Nora had an old gander that was mean as a snake. He would stick his neck out and hiss and take a bite out of me every time I went to her

house. I was deathly afraid of him. He never liked me, and I never liked him—that's a fact.

And then there was Walt, my oldest sibling. He married Nancy Williamson, and they had four children—Frank, Hazel, Walter Alan and Sherrill. Walt lived to be ninety-four.

His son Alan fought in World War II. Walt and Walter Alan were the only two of my family members who were in the military, Walt in World War I, and Walter Alan in World War II. But Walter Alan wasn't as fortunate as his dad. He was killed on the same island, Ie Shima (later known as Iejima), where the famous war correspondent Ernie Pyle was killed. Pyle stayed with us for quite a while when Dick and I ran the Hotel Greystone. But now I am getting way ahead of myself.

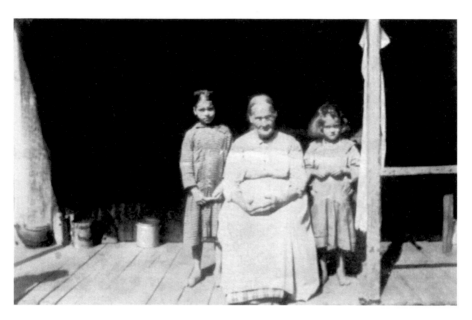

Johnnie (right) and I with Granny. I was the apple of Granny's eye, and I knew it. *Courtesy of Martha and Richard Renfro.*

Life on the Farm

We were poor, but I didn't know it. We had enough to eat and clothes to wear, a warm house and lots of love. We had a mop and a broom for cleaning—no fancy gadgets. We had time to sit on the front porch and visit with the neighbors while we snapped beans, shucked corn and peeled apples.

When we gathered for corn shucking, we all hoped to find a solid red ear. That meant you got to kiss your sweetheart, but that didn't happen very often. Those red ears were scarce as a hen's teeth.

We farmed and raised most of our own food. We had an orchard with fifty to seventy-five trees. Dad knew how to graft sweet apples to sour apples. We had trees that had both kinds of apples on the same tree. We had Winesaps and Pippins and a lot of varieties you never hear of now—Abraham, Rusty Coat, Sour John, Black Limbertwig, Red June, White June and Sour Johns—they didn't ripen until winter, and they made good jelly. Sour Early Harvest was my favorite pie apple. Now I use Granny Smith apples for my pies.

We didn't have nursery catalogues like we do now, so we made up names for the hybrids—whatever we thought they should be, homemade names that sounded right. And Dad never had to spray; we didn't have bugs and worms like we have now.

We furnished all the neighbors with apples, and they would come over to use our big apple corer. Four or five people would peel, while another cut, while another turned the crank on the corer. The coring went much faster than the peeling.

Then we all dried apples in a big dry kiln Dad built. It had shelves in it and a big furnace underneath the shelves. The boys stayed with it all night and tended the fire. We could dry about five bushels a night. We did this for the neighbors, too. When the process was finished, the reward for the boys was to pop corn or roast potatoes in the ashes.

Some of the apples we sulphured. That's something no one does any more. We put layers of apples in a keg and a saucer of sulphur on top of the apples. Then we covered the barrel and left the apples overnight. When the sulphur burned up, we added another layer of apples and more sulphur and repeated the process. This made the apples stay as hard as when we peeled them. I didn't like them because they had a sulphury taste.

We buried apples and potatoes, too, on a bed of straw, covered them with more straw and put planks on to keep them from getting wet. We could keep apples and potatoes all winter like that.

In addition to drying and sulphuring, we canned apples and made apple butter, apple jelly, applesauce, apple pies and apple cider. You can see why the apple orchard was important to our daily sustenance. To this day, I love apple pies and apples, but not the rest of it.

On our farmland, we grew just about any vegetable you can think of—squash, peas, beans, turnips, cabbage, potatoes, beets and corn. Green beans and beets were my favorites, and I still would rather have half-runner green beans than any other food.

Syd and Julius helped Dad with the plowing. Johnnie and I hoed. We took turns coming home to fix dinner in the middle of the day. They used to say you slept better if you ate your big meal in the middle of the day. It may surprise you to know that both Johnnie and I preferred to be outside working in the field to inside cooking dinner.

We had a root cellar for storing things like turnips and cabbage. And we had a springhouse a half mile from the house where we kept milk and butter in a big box with a bottom in it that Dad made.

We did all our cooking on a coal-burning stove. Coal makes hotter heat than wood. We had an oven, but it had no thermostat, so baking was a trial-and-error process. It depended on how hot the fire was as to how fast the cake baked.

We mostly ate vegetables, fruit, biscuits and cornbread. We ate healthy, and we mostly stayed healthy. And that's a good thing because there weren't many remedies. We had iodine, Epsom salts and castor oil, and Dad took Black Draught as a laxative. That was all we had.

We did occasionally have meat. We raised chickens, and they produced our eggs. But on special occasions, we had chicken for dinner. That occasion was usually when the itinerant preacher came on his monthly route through Sugarlands. He stayed with different families; once in awhile, he stayed with us. The story has always been that preachers love fried chicken; maybe that's where the tradition started.

We also had two cows at a time, which produced our milk, raw milk. We had never heard of pasteurized milk. And we churned our own butter; I have churned a lot of butter in my day.

When a cow was about to have a calf, Dad had to let her dry up until the calf was born. Then the milk would come again. We didn't raise cows for beef.

We did fatten four hogs a year. Dad fed them only corn for six weeks before slaughtering. That plumped them up in a hurry. We butchered in the fall on a cold day. After the hog was dead, we poured boiling water over the hogs and then scraped the hair off. The neighbors came to help. We used everything but the squeal and the tail. We used the good fat for cooking and the rendered fat from around the intestines for soap. To render fat, we took the large swath of fat, called leaf lard, from around the hog intestines and fried it out. That produced the grease used to make lye soap. More about that later.

We rubbed the hams and side meat—some call it streaked meat—with brown sugar, salt and black pepper; put the hams and salt pork in a big box for six weeks; and then hung it in the smokehouse for several days. After the smoking process, it could hang there until we needed it; it was cured, so it wouldn't go bad.

We cooked the hog heads to make souse meat, which we ground and seasoned with sage. We made our own sausage using a hand-crank sausage mill. I poked the meat in, and Dad turned the crank. Four hogs lasted us a whole year.

After the hog slaughtering, we had rendered fat with which to make soap. But first we had to make lye, the other ingredient in our soap. We had two big ash hoppers that sloped at the bottom and had a lid on top. We only burned hardwood, mostly oak, for this. We poured the ashes into the hopper and poured water over the ashes, and what came out through the spout was lye. We mixed that with rendered grease to produce soap. It was soft, not in cakes. We used our hands or a cup to scoop up what we needed.

Laundry time happened down by the river, where we had a big black kettle on two poles. We boiled everything in lye soapsuds and then rinsed

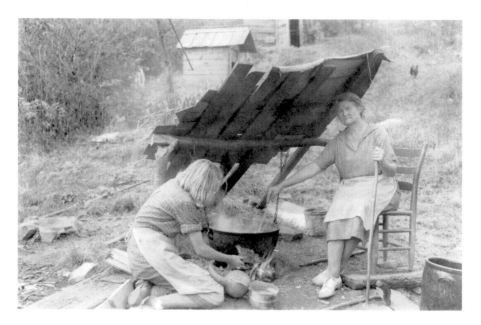

Unidentified ladies making soap, pioneer style (1935). *Courtesy of Great Smoky Mountains National Park Archives.*

them in a tub and hung them out to dry. Our whites were sparkling white. Tide commercials boast that "It keeps your white things whiter," but it has nothing on us and our lye soap.

All of us mountain people believed that "cleanliness is next to godliness." Mr. Prickett, my very first schoolteacher, used to say, "I don't care how ragged you come to school, just come clean." There was no shame in being raggedy, but there was no excuse for being dirty. It makes me angry that in movies like the ever-popular *Christie*, the Appalachian people are shown raggedy, barefoot and dirty. It just wasn't so.

The hardwood ashes from the making of lye were also an essential ingredient in the making of hominy. No one makes hominy homemade anymore; you just buy it in a can. But we made our own, and it was quite an ordeal.

You had to have November corn that had been dried. Then we covered a gallon of corn with water, tied a quart of hardwood ashes (used in the making of the lye) in muslin and threw that in with the corn. It had to cook until the skin on the corn kernels would slip off when you pressed them between your thumb and forefinger. Next, we removed the ashes, washed the corn three times, cooked the skinned corn for another hour

and washed it again. We had to repeat this process three times until all the lye was removed. Finally, we cooked the corn until it was soft. The process took about six hours. You can see why folks buy it in a can now.

One time, not too long ago, I went to a restaurant, and for some reason I told the people I was with that I used to make hominy. They seemed interested, so I went through the whole story about how to make it. When I finished, a lady asked, "What do you do with hominy?" I guess she doesn't even buy it in a can.

What we couldn't produce ourselves, we got from McCarter's Store in town. We thought anyone who owned a store was really somebody. We got our coffee, sugar and flour there. Sometimes we traded eggs or a cured ham for those things the old-fashioned barter system. There's a lot to be said for doing business that way. One year, eggs went from twenty-five or thirty cents to sixty cents a dozen. We thought we were rich.

My favorite holiday was Christmas because it was the only time of year that we had oranges. We didn't get gifts, but we all hung stockings from the mantle. And in our stockings we got nuts, a candy cane and those beloved oranges.

We had a cedar Christmas tree we cut from our farm. We strung popcorn and cranberries and made paper chains from red and green paper to decorate it with.

It had no lights. There were no electric tree lights back then, and we had no electricity. But the occasion was no less festive. Christmas dinner was generally the same as any other dinner, except my brothers sometimes killed a wild turkey, or four or five, for the occasion.

I didn't care about the turkey meat, but I loved making fans out of the tail feathers. We spread the feathers, put the iron or weights on them and let them dry, and then we had a big turkey-tail fan. We fanned the fire to make it blaze and then hung the fan beside the chimney.

Life wasn't all work and no play. My favorite thing to do for entertainment was to go into town to the big red Barn at the Settlement School to see movies. One of the Pi Phi fraternity chapters had sent out a film projector. So the first movie anyone saw in Gatlinburg was shown at the Barn. They mostly showed westerns. There was only one boy in Sugarlands who had a car, and he had a girlfriend in town. That was fortunate for us because he would let us stand on the running boards of his car and ride the three miles into town. Sometimes there were six or eight of us hangers-on. I don't know what kind of car it was; it had a long pointed front end. I just know we had a great time hitching a ride.

I had a good upbringing. All of us were loved, happy and self-sufficient. I think kids now might freeze to death or starve to death under similar circumstances, but not me because I know how it's done.

When I think about my Granny Whaley, I think of her as teacher, worker, cook and our family's rock and foundation. Other words that describe her include strong, classy, beautiful, loving and faithful.

Growing up, I heard stories of the hard work and sacrifice that she endured when she was young. I remember her saying, "We were poor, and we worked for everything we had." I was taught by my granny and my granddad that you should work hard for what you have. I recall Granny telling us how important education was because she didn't have much of one. Then Granddad would chime in, "Your education is the only thing that cannot be taken away from you." Growing up with these words of wisdom from my grandparents has made me who I am today. Those words pushed me to work hard, get a good education and provide for my family.

Granny is such a smart woman and great teacher. When I was very little, I remember her teaching me to play gin. I was so young that I couldn't hold all my cards in one hand, but that didn't faze Granny. She expected me to learn like anyone else. Pretty soon, I learned the game and was able to beat her from time to time. I took up crossword puzzles and word finds because that is what she loved to do. She also loved to read, and I found that interesting, so of course I wanted to like to read as well. I think I am the only other family member who loves a good book. When you ask her what her secret is to longevity, she says to stay interested in something and keep your mind going. She has certainly done that.

People tell me all the time how lucky I am to have her in my life; I agree. She is truly an amazing lady. We are lucky to have had her here with us for as long as we have, and I hope to keep her here for many more years. But when it is her time to go home to our Savior, I will always remember her beautiful smile and loving heart. I hope and pray that I can be like her in some way throughout my life. She will leave a living legacy in all those whose lives she touched. I feel blessed to call her Granny.

Kerri Ogle Jones

A Passion for School and Reading

My school days were happy days. My brothers did not like school, but I loved it. My first two years of school were spent in the United Brethren Church because there was no schoolhouse in Sugarlands. There was a big curtain up the middle of the room. Grades one through four met on one side and grades five through eight on the other. Mr. Prickett was my first teacher. He taught all the grades and all the subjects. My first reader was simply called *Primer*.

Mr. Prickett did not have a wife or a house. He had a precious little white dog named Flip that went everywhere with him. Sometimes Mr. Prickett stayed in a boardinghouse in Gatlinburg, and sometimes he stayed with the families of his students. Everyone liked him and welcomed him into their homes. Mr. Prickett joins Dad on my list of most influential people in my life.

When I was eight or nine years old, the county built a schoolhouse in Sugarlands. It had two rooms with closets and a potbellied stove on legs. It burned coal that had to be shipped in by train from Sevierville. And we had "his" and "hers" outhouses. We had wooden desks that seated two. We wrote on paper; slates were before my time!

In 1912, the Pi Beta Phi fraternity had founded the first Settlement School in the area down in town on thirty-five acres of land purchased from E.E. Ogle. Andy Huff and Steve Whaley, who would one day be my father-in-law, were instrumental in raising the money.

Teachers' cottage in Sugarlands (1927). *Courtesy of Great Smoky Mountains National Park Archives.*

The Pi Phis' goal was to educate the mountain children and to preserve the mountain crafts. The school just celebrated its 100th birthday in 2012. Those were really ladies with a mission and a vision.

The Pi Phis also built a cottage for two teachers up at the Sugarlands School and sent us Helen Chew, a Pi Phi from Ohio. The county hired Cora McCarter, a local girl who graduated from Carson-Newman College, to be her assistant. The cottage had running water, the first I had ever seen. I thought that was amazing. I loved the Pi Phi teachers who came to teach us up in Sugarlands. Miss Chew is the other "most influential" person in my life.

That first Thanksgiving, Miss Chew and Miss McCarter cooked Thanksgiving dinner for all of us. I made a white cake with chocolate frosting and brought it to the dinner. I had never made a cake before, and I don't know what made me think I could do it, but I did it. I just wanted to do something for my teachers.

The school day began at 8:00 a.m. and ended at 4:00 p.m., and the school year ran from the first of September through the end of January. We walked to school, a mile or a mile and a half each way. I'm not a very good judge of distance, I'm afraid. We crossed the Middle Prong of the Little Pigeon River by way of a swinging bridge. Just before the bridge, we passed an old man's apple orchard. We helped ourselves to the apples on the way to school.

Teacher Miss Helen Chew standing with neighbor Burton Ogle on the swinging bridge I crossed every day to get to school. *Courtesy of Great Smoky Mountains National Park Archives.*

Most days, we Cole children walked home for lunch since that was our main meal of the day. All the students who were near enough did the same. Somehow we made it there and back in the hour allotted. At night, we ate leftovers, corn bread and milk. Sometimes we packed a lunch in a hinged tin lunch pail—usually biscuits, jelly, a leftover ear of corn and milk, which we sat in the spring near the school.

After school, we either went to our apple orchard or garden for a snack—no Fruit Roll-Ups, juice boxes, ice cream or chips. We'd sometimes eat the tops of the onions before the onions were big enough to pull. That really made Dad fuss because then he didn't know where the onions were. I wonder what my grandchildren would think if I offered them young onion tops for a snack?

My best friend in school was Mae McCarter. I always sat with her. I remember how she giggled so much, kind of a nervous giggle. I loved her a lot.

Mae's brother Estel and I were competitors in everything—arithmetic, spelling and reading. (It was his dad who owned the store where we shopped in town.) We both made good grades in every subject.

We had to memorize a lot. The teachers gave us little cards with Bible verses to learn. We were all supposed to memorize the Lord's Prayer, the Beatitudes, the Ten Commandments, Psalm 23, Psalm 100 and one other psalm—I can't remember which one. But Estel and I were the first

two students to accomplish it. We were each presented with a Bible. I still have it somewhere. I was so proud.

We had to stand to read and to recite our lessons. We also had to stand and sing. My singing partner was Stella Carey. I sadly did not inherit Dad's beautiful singing voice, but I still can "make a joyful noise unto the Lord." Nor did I inherit his knack for penmanship. I blamed my poor handwriting on the fact that I was left-handed. I don't know whether there's any truth to that or not.

But boy, could I spell. I loved the spelling bees we had after recess each day. Estel and I were fierce competitors there, too. On Friday afternoons, we went from the Sugarlands School to compete in spelling bees at Forks-of-the-River School, located where the park headquarters is now, or to Brackins School, near the Chimneys campground. I do not understand why children today cannot spell. It just doesn't make sense to me that this is not stressed in school anymore.

Reading was my passion. I read every Zane Grey novel I could get my hands on. There was no school library or public library back then, so I bought books as fast as I could save up money. When I had fifty cents, I had a new Zane Grey novel. He wrote westerns, adventure novels and short stories. I didn't read his westerns, but the adventure novels were

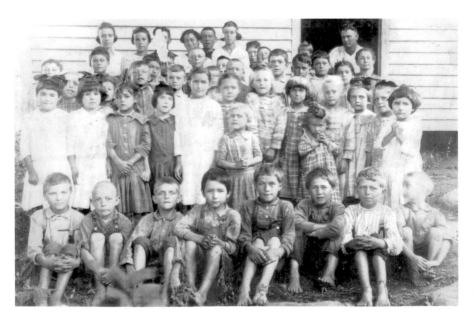

Sugarlands School photo, 1921. Teacher Elmer Watson, in the doorway, rode his horse from Gatlinburg every day. I am the short girl in front of him. *Martha Whaley's collection.*

fantastic. I loved *Desert Gold*, but *Riders of the Purple Sage* was my favorite and his all-time bestselling book. I still remember those two titles; they popped right into my head as soon as I thought of Zane Grey.

I loved school. I made good grades, the teachers loved me and I loved the teachers. What was not to love?

I loved school so much that I went to eighth grade twice. I couldn't leave home to go to high school because Mom was too sick. I was needed to cook and help at home. But Dad did let me go to eighth grade another year. Then that was the end of my education. After Mom died, I headed into town to get a job and start a life of my own.

Mountain View Hotel, the first hotel in Gatlinburg—where I got my first job after coming into town from Sugarlands. *Martha Whaley's collection.*

Riverside Hotel, the second Gatlinburg hotel, built by my in-laws, Pearlie and Stephen Whaley. *Courtesy of Martha and Richard Renfro.*

Life in the Burg

M om died in 1925, and in 1927, at the age of sixteen, I struck out on my own. I moved into Gatlinburg to get a job. I suppose, if I am honest about it, I also hoped to find a husband. Nearly everyone in Sugarlands was married to a third cousin. We all lived there in a big huddle. I hadn't found any marriage material amongst my third cousins, so I knew I had to get out of Sugarlands to find someone.

I need to tell you a little about what Gatlinburg was like back then. There were no paved streets, no streetlights or sidewalks. Locals referred to it simply as "the Burg." Few people had cars. There were so many big rocks in the roads that sometimes folks had to get out of the car and lift the back end up over the rocks before they could proceed.

First Baptist Church had a little frame building on the corner of what are now Cherokee Orchard Road and East Parkway. They had a regular preacher, so there were services every week.

There were only two stores in town. One was Charlie Ogle's store, where the Mountain Mall is now, straight across the street from the church. And the other was Calvin Ogle's store, located at the intersection of Highway 321 and what is now Highway 441.

There were also two hotels. The Mountain View Hotel was there at that same intersection as Calvin's store, and the Riverside Hotel, the original one, was on up the parkway, in town and across the river.

The Mountain View Hotel was built in 1916 by Andy Huff. By 1927, the hotel had running water, bathrooms and electricity provided by Elijah

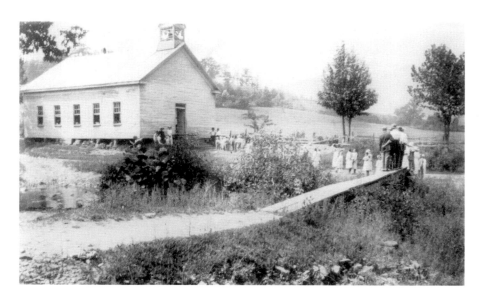

Going to First Baptist Church. *Courtesy of Arrowmont School of Arts and Crafts.*

Charlie Ogle's store in the Burg. *Courtesy of Arrowmont School of Arts and Crafts.*

Reagan, who lived up on Roaring Fork Road. He built a water wheel and installed a turbine and generator to harness the power of Roaring Fork to operate newfangled tools for his woodworking business. He furnished

electricity to his neighbors until the Tennessee Valley Authority began producing inexpensive power for the valley.

And the Riverside Hotel had opened in the Burg in 1925. It was owned by Pearlie and Steve Whaley. Steve had sold his apple orchard on Bullhead Mountain and entered the hospitality arena. That is a very important part of my personal history because their son was to become my husband of almost sixty-three years. But I am getting ahead of myself.

Just around the corner from First Baptist Church was the Pi Beta Phi Settlement School complex with dormitories for the children who couldn't travel back and forth, cottages for the teachers, a building that had been turned into an infirmary and the Barn.

My first job was in the dining room at the Mountain View Hotel. I worked as a waitress there for two seasons, April 1 through October 31. I knew the Whaleys owned the new hotel in town, but I didn't really know any of them. The hotel closed in November, so we were all unemployed six months of the year.

Then Miss Evelyn Bishop, the Settlement School director, asked me if I would like to come be the cook at the school. I was delighted. That was year-round work because even though school closed for the summer, too, the teachers had to be fed, and there were a few students who didn't

The Settlement School, where I worked in the kitchen, my second job in the Burg. *Courtesy of Arrowmont School of Arts and Crafts.*

go home. There was another cook and about fifteen girls who took turns helping us. I loved my job, and they loved our cooking.

I lived in one of the dorms, and it was there that the dorm matron introduced me to crossword puzzles. There was one every day in the *Knoxville News Sentinel*. At some point, they took them out of the paper. We wrote letters of complaint; evidently, a lot of other people did, too, because soon they were back to stay. (I worked the crossword puzzle and did the word jumble every day for decades. I canceled my subscription to the *Sentinel* just six months ago because my eyes have gotten so bad that I can't see the fine print.)

Living in the dorm also meant that I had access to the library at the Settlement School, so I regularly borrowed books. (The Anna Porter Public Library was not yet established.)

In 1927, the Pi Phis had opened a shop, called Arrow Craft, on the corner of Cherokee Orchard Road and the parkway, across from First Baptist. Schoolgirls learned crafts there—basket weaving, cloth weaving, doll making and quilting—and boys learned to make furniture. Many mountain ladies worked out of their homes and brought their crafts to sell there. Mountain folks realized that things they had previously made and used out of necessity were marketable. They could make cash money for them. The cottage industry grew rapidly, and Appalachian crafts were shipped all over the country, mostly marketed by Pi Phi chapters in various cities and states. The Huffs had also opened a gift shop in their hotel to sell the mountain crafts.

At the time, I had a boyfriend who, by the way, was one of my third cousins. We dated for two years, and we always had a good time, but no sparks were flying. Then one day, he just didn't show up for a date. That's the end of that story; he was history.

Soon thereafter, Veatress, one of the girls who worked at Arrow Craft, introduced her boyfriend, Dick Whaley, to me. I had seen him around the Barn; he sometimes helped O.J. Mattill, the agriculture teacher, and as I said, I knew his family owned the new hotel in town. I hadn't really paid much attention.

But I am fairly certain that Veatress quickly wished she had never made that introduction because Dick and I both knew right away that we had found God's plan for our lives.

We started dating. Dick didn't have a car, but we changed a lot of flat tires for other folks on our "dates." Those rocks were hard on tires, so we had a lot of occasions to put our skills to use. Oh, and we went

to movies at the Barn. Sometimes his dad would loan us his Chrysler. I didn't know how to drive, but later Dick's brother Bruce would teach me in that very car.

Dick was also working with Mr. Mattill at his furniture shop. They made walnut and cherry furniture and shipped it all over the country. Dick was making fifty dollars a month; that was a lot of money back then.

After eight months of dating, Dick proposed. I said yes.

Left: Dick Whaley, the love of my life, in his mid-twenties. We have no wedding photos, but this was taken shortly after we were married. *Martha Whaley's collection.*

Right: Me in my mid-twenties. *Martha Whaley's collection.*

The Wedding

There was no such thing as a marriage license back then. Dick did go to Dad and ask for my hand in marriage. Dad asked me if I was sure I loved Dick; I was very sure. I was twenty-one. Dick was six months younger. He always told people, "I married an older woman and one with money." And I did have more than he had.

On a sunny Saturday in June (1931), we went in search of Reverend Pinkney Ownby, whom everyone called Pink. Pink had a farm at the corner of River Road and Ski Mountain Road, where Bennett's Pit Bar-B-Q is now. We knocked on the door, but no one answered. This just couldn't wait.

We trooped off with the two couples who had come as our witnesses, through the milk gap, the space in the fence where cows pass through, and found Pink way out in the pasture.

We decided we would rather be married right there in the pasture than go all the way back to the house, and Pink was happy to oblige. My sister Johnnie and her friend Clyde Ogle and Opal Carey and her boyfriend, Earl Huskey, stood with us.

Clyde and I had dated once upon a time, but I believe you have to wait for the right one. He wasn't it!

Opal and I were best friends. It was her younger sister, Stella, whom I used to sing with at school. Her dad had left Tennessee over twenty years earlier and moved to Colorado, married and had three daughters, but when his wife died, he brought the girls back to Gatlinburg to raise them. I am sure glad he did. Opal and Earl eventually got married, too. Earl

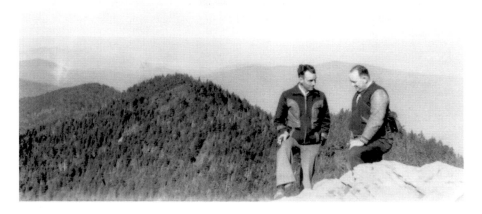

Jim Huff (left) and Dick Whaley atop Mount Le Conte—dressed up hikers indeed. *Martha Whaley's collection.*

had driven us to Pink's; he owned the first *new* car I had ever seen—a 1928 brown Ford coupe.

I was dressed in a navy blue suit that I later loaned to a friend for her wedding. Dick had on a suit and tie. I might add, Dick always wore a tie. His friends teased him about it. One time, when they all hiked to Mount Le Conte, they cut his tie off because they said he didn't need to be wearing a tie.

We didn't have big weddings back then because no one had any money. So there in the pasture covered with wildflowers, Austin Edwin "Dick" Whaley and Martha Cole were united in holy matrimony. (I didn't have a middle name; I guess by the time they got to me, Mom and Dad had run out of names.) When Pink said, "Till death do us part," we thought he meant it. We took our vows very seriously.

For our honeymoon, we went up in the mountains, up past Elkmont, where the log train ran, and we camped out Saturday night. Then we went back to town on Sunday and to work at the Riverside Hotel on Monday.

Miss Bishop and the girls at the Settlement School were happy for me but sad that I had turned in my resignation. Mr. Mattill sheared the sheep at the school; he gave me a lot of wool as a wedding gift. My sister Cora carded the wool and made comforters for our beds. To make comforters, she used fabric on the top and bottom with wool in between and tacked (put a stitch) through all the layers at intervals. What a special gift from two special people in our lives. We put one of them on our first bed, a bed that Dick made himself.

One of my greatest memories of Granny has always been her love for UT football. She can yell for the "orange and white" better than anyone I know. It doesn't get any better than talking sports with Granny while eating a big plate of her delicious fried chicken and biscuits. No one ever leaves a table without Granny making sure they have had enough to eat. Then, just when you think you can't eat another bite, she offers you her famous coconut cream pie.

Today, the memories are continuing, with my two girls loving to help Granny roll out her homemade rolls for strawberry jelly. With her warm smile, yummy food and passion for UT football, my granny will always be one of a kind!

I love you, Granny.

Scott Ogle

I remember Granny being dressed to the nines. She has always been a classic and timeless beauty. Her lipstick is always on and hair never out of place, very "put together" even when she is standing over the stove with sleeves rolled up frying chicken.

She has had many hobbies. These include cooking, reading and playing cards. Granny never slows down. She is always looking forward to what she's going to do next. Her activity continues to amaze us every day.

Granny is the strongest person I have ever met. She is one of a kind, and we are blessed to call her Granny.

Brooke Andrews Taylor

Life at the Riverside Hotel

Dick went to work as the manager of the Riverside, his parents' hotel, and I managed the dining room and the kitchen. At that time, butter and country ham were both twenty cents a pound. Now butter is four dollars, and country ham is eight or nine dollars a pound. Rooms were fifty cents a night, but it wasn't long until Dick increased the rate to seventy-five cents. Some of the regulars complained, but Steve wouldn't lower the prices. He always stood behind Dick's decisions—that made life much easier for us all

We lived in the hotel. That was really citified to me. The hotel had indoor toilets but no electricity yet. In the kitchen, we still had a coal-burning stove, but it had a thermostat. That made baking so much easier. When we got the stove that had a reservoir for water on the side so that we had hot water to wash dishes, we thought we had arrived. No more boiling water to wash dishes.

Dick's parents had a house next door to the hotel. They took some meals in the dining room, but sometimes they ate at home because Pearlie liked her own cooking.

Pearlie was famous for her homemade ice cream. Every Sunday, she got up and made ice cream before she left for Sunday School and church at First Baptist. (In 1917, when Steve was still farming his land on the west fork of the Little Pigeon River, Pearlie sold her homemade ice cream out of a little shack by the road to visitors who were beginning to come to Gatlinburg en route to the Smoky Mountains.)

We attended church on Wednesday evenings and Sundays at First Baptist Church. There was a lady in the congregation who yelled so loudly that sometimes she made me jump out of my seat. She waved her hands in the air and then ran out of the church yelling. I had never seen anything quite like it, but she didn't scare me away. (I am still a member of First Baptist Church, though now it is in a different location.)

We hadn't been married too long when, one night after dinner, Dick just disappeared. When he finally came back, I said, "Where were you?" He said he had been across the river to wrestle the Montgomery boys. Boys liked to do that back then, but Dick was a married man. I gave him "Hail Columbia," and that never happened again.

It was at the Riverside that I became famous for my biscuits. People always asked me for my recipe. I didn't know what to tell them. I just used a little of this and a pinch of that, and it changed every time I made them, depending on how many people I had to feed. But I would try to make up something that would work.

Dick gave me a run for my money though. He could make some delicious hoecakes that were very popular, too.

During these years in the hotel business, I also developed an aversion to fish. I had never really been a meat eater, but I loved wild trout until I had to cook fish every Friday for our Catholic guests. (Back then, Catholics abstained from eating meat on Fridays.) When we didn't have enough fresh-caught wild trout, we had to fry up frozen fish. It wasn't good at all.

Dick developed a much more serious problem than my distaste for fish. Soon after we were married, he had to have an emergency appendectomy. A side effect was that he got phlebitis in both legs. That prevented him from going into the military during World War II. It was always very painful, and he never got over it. From the time we were married for four or five years until he died in 1994, he had to wear support stockings. But he was not a complainer.

All the locals called Stephen Whaley "Uncle Steve." He had a great sense of humor. He could always get folks laughing. One time, someone asked Uncle Steve what he did for a living. He pointed to Pearlie and said, "That old lady over there owns the hotel, and she makes me work."

Uncle Steve always smoked a cigar—smoked it right down to nothing. Then he'd stick a toothpick in the nub and smoke it some more. We'd find the toothpicks lying around everywhere.

I learned to drive after we were married, but it wasn't Dick who taught me. I'm not sure our marriage could have survived that. His brother

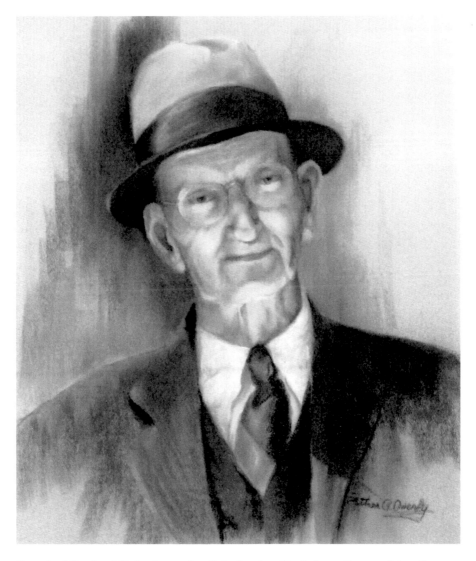

Portrait of Stephen Whaley, known by all the locals as Uncle Steve. *Courtesy of Anna Porter Public Library, from the collection of Wilma Maples.*

Bruce took me out in Uncle Steve's old Chrysler, the same one Dick and I used when we were dating. He had me drive up to the CCC (Civilian Conservation Corps) camp, where Sugarlands Visitors' Center is now, and then back into town. I don't know how many times we did that, but eventually I got my driver's license. The first car Dick and I had of our own was a Plymouth.

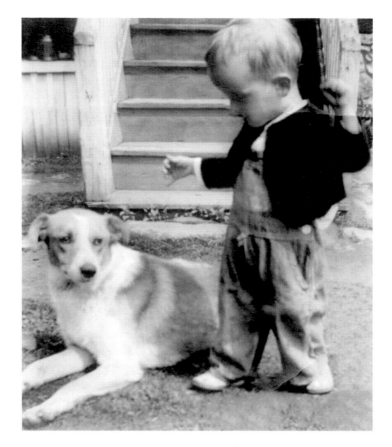

Little Bob Whaley all dressed up with his dog Sandy. *Martha Whaley's collection.*

But the most momentous event of our ten years at the Riverside was the birth of our son Robert "Bob" Joseph in 1933. And the second was the opening of the Great Smoky Mountains National Park in 1934. Dr. Harold Ring, who had delivered some three thousand babies in his career, came to our little house on the river for the delivery. But Bob grew up at the hotel. We had an army cot under the table in the kitchen where he took his nap every day. He was everybody's boy. He grew to know all the bellhops and waitresses. They all took care of him. But his favorite was a black boy named Pat.

Bob was a tiny boy, redheaded and freckle-faced. When he was old enough to ride his little scooter up and down the halls of the hotel, he could really cover some ground.

You remember I told you that my sister Cora and her husband, Fred, raised chickens? They sent us fresh eggs, ten or twelve dozen, every two or three weeks. We didn't keep them refrigerated; we didn't have that much cooling space. We just lined the crates up along the walls in the hall outside the kitchen, along with cases of empty glass jars. What does this have to do with Bob? Just wait, I'm getting there.

One day, I heard this big racket in the hall. I rushed out to find Bob with a glass jar in his hand whacking all the fresh eggs. He had broken dozens and dozens of them. He didn't know any better, but I was so mad that I was about to cripple him. (I didn't have patience then, and I'm still sorry about that. But both

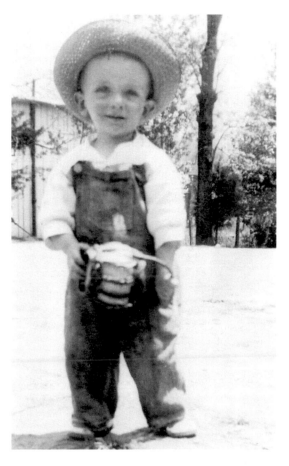

Little Bob sporting his overalls and a big straw farmer's hat. *Martha Whaley's collection.*

my children turned out well, so I guess I did something right.)

He learned to cook standing in a chair beside me in the kitchen, and he was quite good at it. One time, when he was still young, he tried a new recipe. He called out to me and said, "Mommy, where's the cream of torture?"

One year at Easter, we gave him two ducklings. He promptly named them Donald and Daisy—Duck, of course. They were cute as ducklings, but they grew up to be big old ducks that lived behind the hotel for a very long time. One of our celebrity guests, actor Fred McMurray, loved Bob's ducks. Donald and Daisy were something of celebrities in their own right.

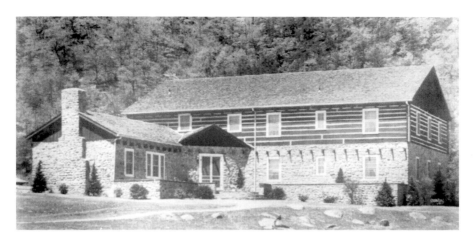

The Gatlinburg Inn, Gatlinburg's third hotel. *Courtesy of Anna Porter Public Library, from the collection of Wilma Maples.*

When it came time for Bob to start school in 1939, he attended the Settlement School. He wanted to play football so badly he could taste it, but he was too little. Instead, he cut out all the newspaper clippings and learned all the stats. We listened to football games on the radio.

Looking back on it now, I think that's why I became such a huge sports enthusiast. But I am just as happy he didn't play football. Those athletes make a pile of money, but it's so dangerous. Being healthy is everything. Fortunately, he loved school, even without the sports, and he was a good student. He never did grow tall; he was only five feet, six inches tall as an adult—short for a man, by anyone's standards.

That same year, the Gatlinburg Inn opened, Gatlinburg's third hotel. Dick was convinced that we should build a hotel of our own. Tourism was flourishing due to the opening of the park. People slept in their cars by the sides of the road because they couldn't get rooms.

But the park had also displaced hundreds of families who owned the land that was incorporated into it. That included my family.

My dad was Jess, Martha's brother. He was fourteen years older than Martha. My first memory of Aunt Martha was when she and Aunt Johnnie, and sometimes Aunt Mag, came every week out to Waldens Creek to clean the house for Grandpa and Uncle Syd. They lived at the bottom of the hill by the road. We lived at the top of the hill, just about an eighth of a mile apart. When blackberries were in, my twin sister Judy, my brother Charles and I picked all we could in advance because we knew Aunt Martha would pay us fifty cents a gallon. Everyone else paid twenty-five cents. We thought we were in high cotton.

As an adult, I remember the wonderful family gatherings at the Chimneys Picnic Area, where Martha fried chicken in these enormous cast-iron skillets. She had at least one of chicken and one of potatoes going at the same time, depending on how many folks there were. Martha likes to cut her own chickens because she has a certain way of doing it so that every piece has some white meat on it. I've never known anyone else who cuts chicken like that. Martha's fried chicken is some fine fried chicken.

My husband, Bill, and I have enjoyed sharing vegetables from our garden over in Hillsborough Acres because Martha loves vegetables. I used to break the beans for her, but then her daughter Robin told me she

Relaxing after frying up a big skillet of my famous fried chicken at a picnic at the Chimneys picnic area. *Courtesy of Jody Cole Allen.*

loved to break beans, so I just quit doing that! If it wasn't too late in the day when we brought the vegetables, Martha wanted to feed us. I think Martha feeds everybody.

I love Martha's love for life. She is always bubbly. She is a beautiful southern lady. She's a godly lady. She's the type of person you would just like to wind up and keep going forever, like the Energizer bunny. It is her love of life that has kept her going for over ten decades.

Jody Cole Allen

Creation of the Great Smoky Mountains National Park

For those readers who may not know, let me give a little history lesson. In 1926, President Calvin Coolidge signed a bill providing for the establishment of the Great Smoky Mountains National Park. The Department of the Interior was to assume responsibility for the administration and protection of the park in the Smokies as soon as 150,000 acres of land had been purchased.

The Tennessee and North Carolina legislatures appropriated $2 million each for land purchases. Additional dollars were raised by individuals, private groups and even children who pledged their pennies. By 1928, $5 million had been raised. The Laura Spelman Rockefeller Memorial Fund donated $5 million more to ensure the purchase of the remaining land needed to form the park.

But getting the money was only half the battle. The land had to be purchased from many who were not happy to relinquish it. The timber and paper companies had valuable equipment on that land, and the trees were their inventory. They had to be compensated handsomely.

Some families who were located on that land were happy to have cash in hand and left willingly. Some found it an inconvenience to have to break up housekeeping and reestablish themselves somewhere else. Others were paid and given permission to continue to live on the land until the original owner died. Still others were just plain hostile to the whole idea; my dad was one of those.

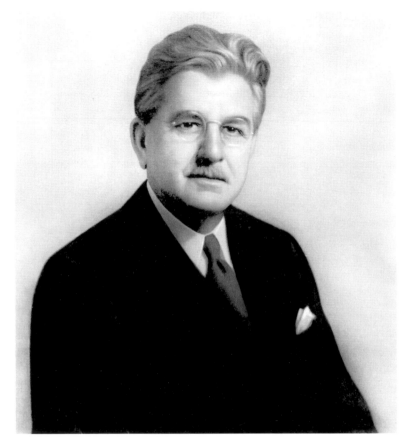

Portrait of David C. Chapman, who finally persuaded Dad to sell his land to the government. *Courtesy of Great Smoky Mountains National Park Archives.*

Men came from Knoxville to talk to Dad. David Chapman was the Tennessee leader of the park campaign. He was a prominent politician, president of a Knoxville drug company and chairman of the Great Smoky Mountains Conservation Association. He was at our house a lot. (He is the Chapman for whom Chapman Highway was later named.) Finally, he wore Dad down, and Dad agreed to sell his forty acres for the handsome sum of $40,000. His plan was to continue to live in the park, but like many other farmers, he found he couldn't abide the rules.

The park regulations said people couldn't tap the maple trees. They couldn't protect their chickens and pigs from wild animals. People weren't allowed to hunt and trap. They couldn't cut timber or otherwise

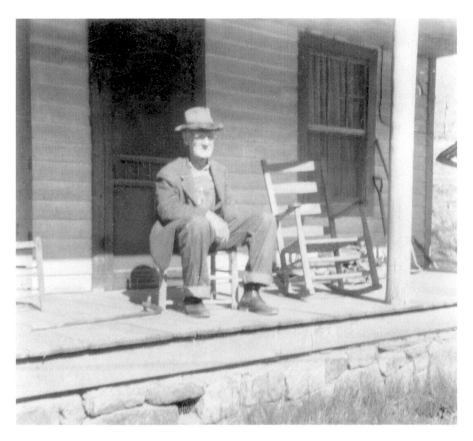

Dad on the porch of his Waldens Creek house. *Martha Whaley's collection.*

live as they always had. Dad found it impossible to maintain his way of life, so he bought a piece of land out on Waldens Creek in Pigeon Forge, built a little frame house and he and Syd moved. Johnnie and I went once a week to clean his house and take them food.

Mom and Granny are buried in Sugarlands, but Dad and Syd are buried in Shiloh Memorial Gardens between Pigeon Forge and Sevierville. It broke his heart to leave Sugarlands. He said he didn't ever want to go back, not even to be buried.

But plans for the park proceeded in spite of folks like Dad. Ross Eakin (pronounced A-kin) was hired as the first park superintendent. He arrived in 1931 and remained until 1945. By 1934, Tennessee and North Carolina had transferred deeds for 300,000 acres of land to the federal government. The Civilian Conservation Corps started building

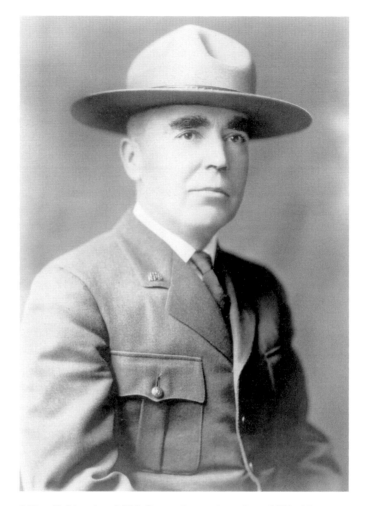

J. Ross Eakin, circa 1930, first park superintendent, 1931–45.
Courtesy of Great Smoky Mountains National Park Archives.

facilities and restoring early settlers' buildings in 1933 and continued through 1942.

The park officially opened in 1934 and was dedicated by Franklin D. Roosevelt on September 2, 1940. I would like to tell you that I was at Newfound Gap to hear him speak or that I actually got to shake his hand. But I was working. The Mountain View and the Riverside prepared all the food for the visiting dignitaries. I personally made all the cakes.

Roosevelt's motorcade did go by the Riverside. The top was down on his car, and the president waved to us, so we did get to see him.

President Franklin D. Roosevelt speaking at the dedication of the Great Smoky Mountains National Park, September 2, 1940, Newfound Gap. *Courtesy of Great Smoky Mountains National Park Archives.*

Though some people didn't want the park and its establishment displaced many families, including my own, I think it has been a good thing. The park built the tourist industry, which caused Gatlinburg to grow and its citizens to prosper. More importantly, the park keeps civilization from destroying the land (now over 500,000 acres), which

is home to 30 species of salamanders and 240 species of birds, 60 of which are year-round residents in the park. No building can go into it. No billboards can be put up. No trees can be cut down. It is available for all to see and enjoy, and it is the only national park that has no admission fee.

I might add that Dick and I not only enjoyed the park and profited from the tourism business, but we also knew all the park superintendents from Ross Eakin on, and they were all awful nice folks. A number of them became personal friends, among them Fred Overly and his wife, Esther. Fred was park superintendent from June 1958 until May 1963. We did lots of things together. They went with us on many fishing trips. Esther was always fun to be around, but she didn't have a lick of common sense, and she was very impulsive.

One time, we were at a dinner party for Senator Estes Kefauver. His wife, Nancy, who was an artist, was there, too. Esther said some insulting things. Fred fussed at her when they got home. She said, "Well, I just say what I think." And that was certainly true. Fred said, "She needs to bridle her tongue." And that was also certainly true.

Esther and Fred had a daughter who lived in Washington, D.C., near my sister Johnnie in Arlington. She was going to drive up for a visit and invited me to go with her. I had my bags packed. Two days before we were to leave, she called and said her other daughter from Johnson City wanted to go, so there wouldn't be room for me. I was madder than a wet hen. But she was hard to stay mad at, and our friendship survived.

Fred made an important contribution to our area while he was park superintendent. He wanted to create the Roaring Fork Motor Nature Trail, a six-mile, one-way loop through the park that takes sightseers and nature lovers five thousand feet up along the northern slopes of Mount Le Conte.

The park wouldn't approve the project, so he just went ahead and did it. I don't know how he got the work funded or carried out, but it happened. All the locals called it the Fred Overly Loop. It's still a favorite with tourists and locals. It offers something different in every season of the year.

Though my childhood home was torn down, the park relocated Granny's cabin to the Loop. It is called the A.A. Cole cabin, I guess because, in the end, it was added to Dad's bigger house.

As far as I know, there has been only one feature film made in the park. That was the Ingrid Bergman and Anthony Quinn movie *A Walk in the*

Spring Rain. It was filmed in Cades Cove in 1970. Bergman and Quinn stayed in town. It caused quite a stir in the Burg.

One final note about the park: The last surviving resident, who was "grandfathered in" when the park was created and elected to continue living on his land, died in Cades Cove in 1999. That was Kermit Caughron. Now the park truly belongs to everyone. There are no more families living on family land.

We did it—the new Hotel Greystone opened in April 1942. *Martha Whaley's collection.*

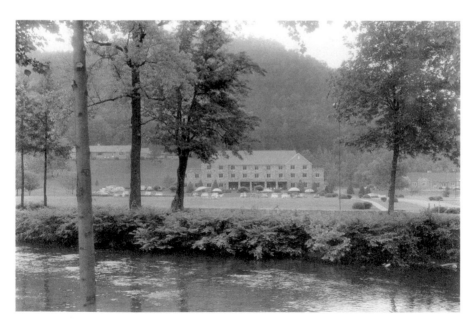

The Hotel Greystone, 1952. Tourists loved its tranquility with the mountains behind and the water in front. *Courtesy of Great Smoky Mountains National Park Archives.*

The Greystone Years

D ick had a good head for business. The Riverside was thriving, and
though he was part owner, he wanted to have his own hotel. His
dad owned property farther on down the parkway, on the corner where
Ripley's Aquarium stands now. Dick traded his share in the Riverside
for that property, and construction began on the Hotel Greystone in
December 1941. We wondered if we would have any business because
World War II had just begun, but we forged ahead.

Dick's brother, Bruce, took over the Riverside until he went into the
war. Then his sister Blanche ran it. Construction on the Greystone moved
quickly, and we opened it in April 1942.

Again, Dick managed the hotel, and I ran the dining room. Both my
sister Cora and my sister Mag worked for us as pastry chefs for years at
the Greystone. We never fussed; they were hard workers. We always got
along. I think that is rare, especially for three women.

People not only came, but many of them came and stayed for the entire
summer. Gas was being rationed, so it was more economical to make just
one summer excursion. And we had many families of servicemen who
spent the summers during the war years with us. Our opening year rates
were fifty cents for a room and fifty cents for meals.

The Mountain View, the Riverside and the Greystone each had two
touring cars to take the guests sightseeing. They were convertibles. One
of ours was a big Studebaker with a heater in the bottom that got so hot
I called it "the furnace." We hired drivers to take guests over to Cherokee

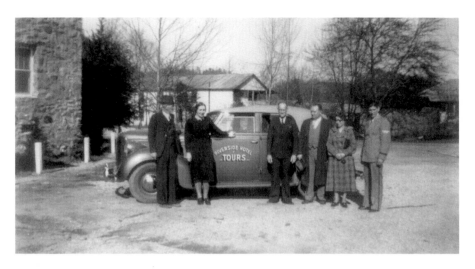

Riverside Hotel touring car. Steve Whaley (far left) and Dick Whaley (third from the right) with tourists, 1938. *Martha Whaley's collection.*

and on to Asheville in a big loop. It was an all-day drive. Tourists loved those tours.

Everything was rationed during the war years, not just gas. Even the hotel had ration stamps. I remember needing new shoes, but I didn't have stamps for shoes. I went down to the shoe store to talk to Rose Maples (Roosevelt) about my problem. He said, "Rationing don't say anything about slippers, so I guess I can sell you a pair of slippers."

The ladies of Gatlinburg tried to do our part for the war effort. The Red Cross put out a call for people to knit sweaters for children and adults. We formed a group called "Knittin' for Britain." We met at Miss Evelyn's beautiful cottage on the Settlement School campus behind the Mountain View Hotel. We knitted sweaters and sewed snowsuits for children. Twelve of us met every week for almost a year.

I liked to knit, but I despised sewing pieces together. Unfortunately, so did a lot of the other ladies. They brought their pieces to me. Thank goodness for my good friend Ruth Galbraith, who sewed beautifully. She was willing to help.

The same year the war ended, 1945, Gatlinburg was incorporated, and Dick was elected the town's first mayor. Dick was a Republican, like nearly everyone else in the county. Oh, both his brother and sister were Democrats, but they were the odd ones out. People didn't discuss politics much in Gatlinburg because basically everyone agreed on nearly anything

that might have been an issue elsewhere. Dick's friends insisted that he was the right man for the job. Once, at midnight, the phone rang at our house. A lady said, "There is a dead dog in my driveway. Come get rid of it." Dick went, but he said then and there that was his first and last venture into politics.

In 1947, we sent Bob to military school in Columbia, Tennessee. We were sure he would have to go into the military, and we wanted him to enlist with rank. He went. He hated it. He begged to come home, but Dick said no. He had changed high schools three times himself, and he did not believe the change would be good for Bob, so he stayed.

Bob Whaley in his military school uniform. *Martha Whaley's collection.*

Ironically, his childhood asthma returned while he was in military school, and that prevented him from ever doing military service.

We had added a building behind the Greystone that looked like a house on the outside. It was just one big, long room inside in which we could set up for big banquets. We nicknamed it "the Playhouse." In 1950 or '51, we hosted a three-night Governors' Conference. Nearly all the governors stayed with us, and we fed them in the Playhouse. We cooked barbecue in a big pit in the ground. Men stayed all night with the pig. The Buick family furnished cars for the governors to drive.

In the fall of 1951, Bob enrolled at the University of Tennessee–Knoxville, and we decided to start spending winters in Florida, where Dick could golf and fish even in the winter and I could escape the cold.

Dick and I enjoying our condominium in Venice, Florida. Do you like the pedal pushers I'm wearing? Dick hated them! *Martha Whaley's collection.*

Winters in Florida

When the hotel closed in November, we headed south to St. Petersburg, Florida. Each year, we came home for Christmas and then went back to Florida until it was time to reopen the hotel on the first of April. At that time, all tourist-related businesses closed for six months of the year. It just wasn't profitable to keep them open.

It was a nice little town, though I didn't drive when we were there because there was too much traffic. But you know, I've only been stopped by the police once in all my years of driving, and that was for a license check. I got so nervous that I couldn't find my license. The officer laughed and said, "I see it right there in your purse. Go on."

Johnnie and Otto came for six weeks each winter. Johnnie and I took ceramics classes and macramé lessons and shopped. We could walk anywhere we wanted to go. Then she started having grandchildren, and they didn't come anymore the last few years we lived there.

Johnnie loved the television show *Cannon*. Otto told Johnnie she would look like Cannon if she had a little mustache. We laughed every time he said it.

We had lots of friends, some who went down with us and some whom we met there. On one of our trips in the '50s, we went in a seven-car motorcade. We wore our hillbilly shirts and cowboy boots and stopped in Atlanta and other cities along the way to drum up business. We were quite a sight—country come to town.

Venice, Florida, winter (1978). *From left to right:* Francis Otto, me, Dick, friend XL Hess and Johnnie Otto (right foreground). *Martha Whaley's collection.*

I tried to learn to play golf, but I was left-handed, and the pro insisted that I play right-handed. I said, "Give me a ball as big as a basketball and maybe I can hit it." Needless to say, I never became a golfer.

In the winter of 1954, Bob showed up at the hotel in St. Pete with his new bride, Koleen. Imagine our surprise. He did not go back to college. He managed Whaley Motel, a motel Dick had built on the parkway in Gatlinburg, where McDonald's is now. Koleen finished college and helped Bob at the motel. They wanted children but couldn't have any. They didn't want to adopt. She couldn't cook or sew on a button. Fortunately, Bob was a good cook. It worked for them; they were in love and as happy as could be.

In 1975, we bought a condominium in Venice, Florida, but Venice only had two golf courses, and they got too crowded to suit Dick. So in 1979, we sold that condo and moved to Tarpon Springs, Florida, between Tampa and St. Petersburg.

One year, we decided to go to Tarpon Springs in September. We took two friends with us. It was too hot to fish or to play golf; it was too hot to breathe. We never made that mistake again.

We got rid of the Tarpon Springs condo in 1990, when Dick was no longer able to play golf. I have had enough of Florida. I don't ever want to live there again. It's too flat, too hot and there are no glorious changes of season outside my window.

It has been my privilege to know Martha Whaley for over six decades. I guess I first knew Martha and her husband, Dick, because they had nieces and nephews at the Settlement School (run by Pi Phi fraternity but not called Pi Phi School until 1965). I was teaching business courses there from 1950 to 1953. Then my wife, Jo, and I went into the restaurant business; Martha and Dick were in the hotel business. Town was small. Everybody knew everybody, and we all tried to help each other out. Eventually, I became the owner of the Greystone, and through it all, Jo and Martha were fast friends. When the menfolk traveled to see boxing matches in Atlanta, Birmingham and Durham, the women would go along and shop to their hearts' content.

Martha and Dick were an amazing duo. Dick was a visionary; he started the first bank, capitalized on the tourist boom that he knew would come with the opening of the National Park by building the Hotel Greystone, cofounded the first hotel association, created the first planned housing development—Greystone Heights—and on and on. He could get anybody to do anything. If there was dissension, he could smooth things out. People had so much respect for him.

And Martha was equally well liked and respected. Martha was never on the sidelines. Whatever was going on, she was right in the middle of it. She and Ruth Galbraith, who had worked for Dick when the Greystone first opened, baked all kinds of goodies for Christmas. Sometimes Jo helped them. My favorite: Martha's little pecan balls rolled in powdered sugar.

I would describe Martha as a woman of substance. There was never any question about what she thought about anyone or anything. You don't see much of that anymore. But she had a way of saying what she wanted to say without malice, with a touch of humor.

One day, I was eating lunch at the Mountain Lodge, a local favorite, on busy Highway 321. I saw Martha there, but we were not eating together. All at once, I looked up and saw Martha crossing the four lanes, all by herself, amidst swift traffic in front of the restaurant. I jumped up and ran out, thinking to help her. I caught up to her, and we started chatting.

Martha said, "Oh, are you parked over here, too?"

I said, "No. I thought I would walk you across the street."

She replied, "Well, okay, and when we get there, I'll walk you back across."

That's the Martha we all know and love.

Jack Miller Sr.

The End of the Greystone Years

B elieve it or not, things got progressively worse in the hotel business following the end of World War II. We had had such good help before the war. Crews came, they worked hard and they stayed. But after the war, a lot of folks left the area to work in Oak Ridge because they could make more money. Our cook left. Folks quit with no notice. We dealt with some sorry people. They seemed to be more and more dilatory and lazy. I got fed up with it. I just couldn't handle it anymore. It got so we were so short-staffed that we had to give guests their own linens and tell them to make their own beds.

We never knew whether we were going to have anybody to help. I was about ready for the men in white coats to come and take me away. If you gave me the best place in Gatlinburg to run now, I would not take it.

I guess it was just as well that I was ready to get out of the hotel business, because in 1954, I was pregnant. Bob was twenty-one years old. I was four months along before I could convince my doctor that it was true. Finally, I said, "I feel movement. I know I am pregnant."

I certainly hadn't planned to be, but I was. At that time, I thought it was awful. Now I realize it was the best thing that ever happened. God had a better plan than mine.

I didn't have long to get used to the idea that I was about to be a mother at age forty-four because Robin Ann decided to make her appearance two months early. My local doctor had me rushed by ambulance to Knoxville so that Dr. Lou Hefley, an obstetrician, could deliver my baby by C-section.

My first born, Bob, holding his cousin, Johnnie-Jo Otto. *Martha Whaley's collection.*

Robin weighed just four pounds and had to stay in an incubator until she weighed five pounds. That turned out to be a month. Dr. Hefley told me that sometimes a woman's reproductive organs are at their peak just before she goes through menopause. I guess I was one of those women.

They sent us home with formula. Robin threw it up and cried. I called Dr. Hefley. She said to cook rice and make formula with the rice water. I did. Robin threw that up and continued to cry. My nerves were frayed. At

my wits' end, I made another call, this time to my local doctor, Dr. Cross, who said, "Just put her on plain cow's milk." She took it; problem solved. I was ready to wring Dr. Hefley's neck.

In 1956, we built a house on the mountain behind the Greystone in what is now Greystone Heights. It seemed like a castle to me. It had four bedrooms and four baths. We moved in when Robin was sixteen months old.

We had the first television of anyone on the mountain. We only got one station; it came out of Huntington, West Virginia. All the neighbors gathered in our living room and stared. But the reception was so bad that all we could really see were gray silhouettes of the people, accompanied by sound. Technology has come a long way since then.

It was a good home for the three of us—the only house we ever owned. It was home to Dick and me until 1980, when we moved into the condominium where I still live. I was a stay-at-home mom for the first time in my life. Dick sold the Greystone to Mel Johnson from Memphis, who later sold it to Jack Miller Sr. and partners. Jack eventually bought them out. Jack and his wife, Jo, who died of cancer just a few years ago, were good folks. People stood in line to eat at their restaurant, the Open Hearth. When Dick died in 1994, Jack sent over a whole standing rib

Folks continue to flock to Hotel Greystone—1987 Volkswagen show. *Courtesy of Jack Miller Sr.*

roast for folks to eat. Our Greystone cook, Leroy Manning, went back to work for Jack at the Open Hearth.

The Greystone was a Gatlinburg landmark until March 1998, when it was torn down to make room for Ripley's Aquarium in the Smokies. I hated to see it go, but you can't stop progress. We had a lot of fun, and we worked hard. I think that's why I've never had any problems sleeping. Never any sleeping pills for me.

I had a great childhood growing up in Gatlinburg, although growing up as an only child (my brother was married when I was three months old) caused feelings of loneliness at times. I remember wishing I had brothers and sisters like most of my friends did.

My mother was forty-four when I was born. She was a very good mom. She retired from the hotel business when I was a baby, so she devoted much of her time to me. I had a live-in babysitter named Carrie Burns. She was an older, grandmotherly type. She, along with Mom, did a very good job spoiling me.

Most of my friends' parents were much younger than mine. I remember worrying, at times, that Mom or Dad would get sick or I would lose them.

My teenage years were mostly happy times. My dad did not understand the fashion of the day...like cutoff blue jean shorts and hip-hugger pants. Mom always spoke up and defended me when he fussed about what I wore. She knew the importance of "fitting in" with the crowd.

The greatest lesson I learned from both my parents was honesty: always tell the truth and conduct business with integrity. Dad lived up to those words in his career as a hotel owner/manager and later on as a real estate broker.

Mom's influence on me was the love of cooking. She had a home-cooked (always from scratch) meal on the table every night. Also her attitude of never giving up and always looking on the bright side stays with me even today. She has always tried to live a good Christian life, and she loves the Lord. What better example is there than that? I am truly blessed.

Robin Whaley Andrews

Our Second Family and Beyond

The tourism business had been good to us. But now it was time to move on.

Dick was ready for a new challenge. He started his own real estate business at a time when the real estate business was booming, and he founded Gatlinburg's first bank, First National, which is now BB&T. He was also one of the founding members of the first hotel association in Gatlinburg. The movers and shakers in the hotel business—Andy Huff, owner of the Mountain View; Rel Maples, owner of the Gatlinburg Inn; his brother Bruce Whaley, from the Riverside Hotel; and Jerry McCutcheon, who managed the Mountain View, as well as Herb Holt, the city manager—joined him in this endeavor.

We were both challenged with our role as new parents at age forty-four, and I was at home without a paying job for the first time since I left Dad's house at age fifteen. People who didn't know me would see me with Robin and think I was her grandmother. Well, after all, lots of people are grandparents by the time they are that age, but I was always a bit taken aback when I heard the word "grandmother."

It wasn't a midlife crisis at all. It was more like being newlyweds who were just starting a family. I couldn't help but think of my mother. She had eleven children in twenty years. I had two children twenty years apart. It was like having two "only children."

You remember how I said I didn't have any patience with Bob? Well, that didn't improve with age or with the coming of Robin. I often sent

Above: Founders of the hotel association signing papers to make it official. *Martha Whaley's collection.*

Left: Four-year-old Robin and me on Mother's Day. *Martha Whaley's collection.*

her to play with Mary Ann, daughter of Barbara and Ed Whaley (my nephew and his wife). Mary Ann was four years younger than Robin, but they played well together, and Barbara had enough patience for the both of us. I hope Robin learned that virtue from Barbara. (I always made Ed an apple stack cake for Christmas and a coconut pie for his birthday.)

My favorite Robin stories have to do with dogs. When Robin was two and a half or three years old, our family pet was a border collie named Rags. One day, Robin was standing in a puddle, jumping up and down. I guess Rags's herding instinct got the best of him. He grabbed the hem of her dress and tried to pull her out of the puddle.

Our next dog was a terrier named Troubles. Troubles was our only housedog. Robin dressed Troubles in doll clothes, put her in the stroller and rolled her around. If Robin left the stroller, Troubles sat right there until Robin came back.

Troubles died of cancer while I was on a trip to Japan. A year after she was gone, I still expected her to meet me at the door. I said I never wanted another dog because it's just too hard to give them up. And I haven't had one, but Robin continues to have dogs to this day.

Robin attended Pi Beta Phi Elementary School, previously known as the Settlement School. The new name was adopted in 1965. And then she went on to attend Gatlinburg-Pittman High School. Much to our chagrin, she insisted on getting married when she was seventeen; we couldn't talk her out of it. It's hard to tell a seventeen-year-old anything.

The marriage lasted five years, and the best things to come out of it were her two beautiful children, Scott and Kerri. Robin was the first person to get a divorce on either side of our family. It was traumatic for us all, but it was part of God's plan, because two years later, she married Bill Andrews, who has truly been a blessing to us all.

I had a real heart-to-heart with Robin. I said, "Bill is not just marrying you. He's taking on the children, too." Robin was ready for me. She said, "I know. We've got it all settled." Bill had a daughter, Andrea, from his first marriage. She was eleven; Scott, five; and Kerri, three, when Robin and Bill married. Then they had one child together. Her name is Brooke.

Bill is the best son-in-law anyone could ever have, and he is the workingest man I have ever seen. He's a contractor in Morristown. He has two crews, but he works harder than all of them put together. He leaves the house at daybreak and comes home at dark. Then he feeds their nine horses, comes in and eats and always puts his dishes in the dishwasher.

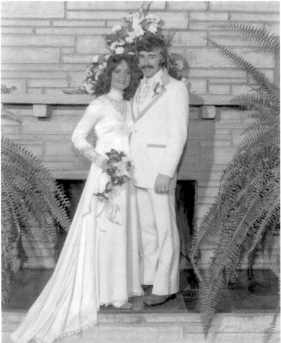

Happily, Bill shares Robin's love of dogs. They have border collies—makes me think of Rags. And of course, he's way up there on my list, too, because he plants a big garden every year, so I have lots of fresh vegetables to eat, to freeze and to can. They have twenty-five acres of land; he has plenty of room to grow things. Can't help but love him!

I recently had a fire in the building where I live. It was an electrical fire that started in the unit under mine. No one was hurt, but we had to evacuate the building. All I kept saying was: "I had fresh green beans and beets cooking on the stove. If Bill is coming to take me to Morristown, someone please go back in and get the beans for him. They are his favorite!"

Top: Dick prepares to give the bride away—Robin's wedding day. *Courtesy of Robin Whaley Andrews.*

Left: The happy couple, Robin and Bill Andrews, January 12, 1979. *Courtesy of Robin Whaley Andrews.*

Beaming over my quarts of freshly canned half-runner green beans.
Courtesy of Robin Whaley Andrews.

When Robin was a teenager, I used to tell her I would never live to see my grandchildren because I was so old when she was born. How happy I am that God has seen fit to let me live to see not only my grandchildren but also ten beautiful great-grandchildren—seven girls and three boys. Andrea has three; Brooke has three, her little Will being the newest great-grandchild; Kerri has two; and Scott has two.

I thank the Lord every day that they are all healthy and happy.

*Falling in love with the right man is the
most important thing I ever did.*

Celebrating our sixtieth wedding anniversary, June 6, 1991. *Martha Whaley's collection.*

The Love of My Life

E ven though this book is about me, I have to dedicate one chapter to the man to whom I was married for just shy of sixty-three years.

Sometimes people asked him or me why he was called "Dick," since his name was Austin Edwin. Seems the governor's name was Dick Austin. Pearlie and Steve were partial to the governor and took to calling their new son "Dick," after Governor Austin. It stuck, and Dick he was for the rest of his life.

Dick was a real "people person." He wanted people around him twenty-four hours a day and company at every meal. He inherited his dad's sense of humor. He could make people laugh and feel at ease. In the hotel business, he had plenty of people to entertain.

He was always looking for ways to be engaged with other people. Bridge afforded him one such opportunity. One day at the hotel, he had played bridge all afternoon, and then he brought those folks home to dinner. "Just feed them what you're gonna' have anyway," he said. I think I fixed salmon croquettes, not exactly what you would plan to feed company, but that's what I had planned to feed Dick. I was mad the whole time because he didn't let me know ahead of time that he was bringing home guests, but you couldn't help but love him—everyone did.

Dick's love of people went everywhere he went. He didn't leave it back in Gatlinburg. In Tarpon Springs, he played golf instead of bridge. Same story. He brought all his golf buddies home for dinner, even when he hadn't alerted me that they were coming.

He never understood why that bothered me. Never mind that I might have been planning to have leftovers or that I couldn't stretch what I had planned enough to "feed the multitudes." But I never disappointed him; I always managed to get a meal on the table that everyone seemed to enjoy. Sharing good times with friends was an important part of who he was.

Dick and I, in our mid-thirties. The smiles say it all, I think. *Courtesy of Robin Whaley Andrews.*

We loved to dance. Baptists may not have believed in dancing, but we just ignored that part of being Baptist. We danced at all the hotel conventions, and we often went to the dances at the Wonderland Hotel in the park. They hosted a dance every Saturday night in the summertime.

I have to confess that Bill Postlewaite, owner and editor of the *Mountain Press*, our local newspaper, was my favorite dance partner. He was a great dancer—so smooth. I wasn't the best dancer, but if you have a good partner who can lead, you can dance.

Dick never envied anyone; his mother was the same way. He figured out what he wanted, and then he worked to make it happen. Dick's sister, Nancy, said it simply and best: "Dick was a giver."

For example, when Robin married so young, and we didn't know how they were going to make it, Dick built the building that later housed Battle's grocery store and tried to set Robin's husband up in business there. Dick put Dad on the payroll and paid him every month, even when he couldn't work anymore. There was nothing selfish or self-centered about Dick.

Dick was so good for me because I was a worrier. He was not. He would always say to me, "If you can worry about it, do something about it. If you can't do anything about it, worrying about it's not going to do a damn bit of good." He lived that philosophy, and it's helped me through a lot of things, especially since I've had to make it without him for nineteen years. What a valuable life lesson.

One thing I didn't have to worry about was finances or business affairs. Dick handled all of that. When he got sick in 1994, I had never even written a check. Bob took it over when Dick couldn't do it anymore, and now Robin does it for me.

I've had a really good life. I couldn't ask for more. In large part, it is because I married Dick Whaley. Falling in love with the right man is the most important thing I ever did in my life.

When I see Martha Whaley, I see a precious soul filled with love, understanding, forgiveness, drive, positive attitude and respect for all. She is the rock of our family who has passed all the tests of time. She is a foundation for Gatlinburg and the Smoky Mountains.

Martha is a mother, a dedicated wife, a great cook, a gardener, a doer of good deeds and a spiritual rock. There will never be another who could fill her shoes.

I have been blessed to be a part of her life.

Bill Andrews

Chapter 14

On Politics

I have always been a Republican. Growing up in Gatlinburg, I didn't realize for years that there was anything else to be. When I was in my teens, there were not enough Democrats to even have a party. Neither my family nor Dick and I took much part in politics. There were just not many avid politicians in this area.

Seventeen presidents have held office in my lifetime. Though Howard Taft was president when I was born, his successor, Woodrow Wilson (1913–1921), is the first one I remember a little bit about.

I was eleven years old when the Nineteenth Amendment passed giving women the right to vote, and I do exercise that hard-earned right. I think it's a right every American citizen should exercise. I have always voted for the man, not the party. I think our best president was Franklin D. Roosevelt, a Democrat. I voted for him twice.

Sadly, I feel that our political system isn't working very well now. Politicians get elected, and then they don't do anything for us when they get there.

What puzzles me more than anything is why we haven't had anyone who will get us fuel. We have to get foreign fuel, and the people who supply it to us all seem to hate us. The oil companies buy off the lobbyists. Experts say we have plenty of natural gas, but the government won't let us pipe it in. I'm sure it's more complicated than that, but I just don't understand. If I could wave a magic wand and fix it, I would.

When we met Martha, she was "only" in her early nineties. We immediately fell in love with her. Her youthful exuberance, energy, wit and presence surpass ours, though we are thirty years younger.

Some of our favorite times with Martha are going on picnics. Martha always insists on bringing the fried chicken and always bakes a pie. Sometimes she even brings Boston baked beans made from scratch. She is a wonderful cook.

A few years ago, we started taking Martha and her neighbor (and our friend) Frances on rides around these beautiful mountains. We go to places like Cades Cove, Metcalf Bottoms, Elkmont, Wears Valley and the Bush Bean Museum. Sometimes we just pick a road and follow it to see where it goes. We have taken Martha to places she has never been in her one-hundred-plus years in Sevier County. One day, when we were "lost," Martha asked, "How will we tell people where we have been?"

Last year, Martha gave us a gift certificate to our favorite restaurant "in appreciation for all the rides we take her on." It was appreciated and accepted with thanks, but we hope she knows that all we want from her is her friendship. We are truly blessed to be among those Martha counts as friends.

Karen and John Daves

On Traveling

I t might seem as if Dick and I were tied down with the hotel business, but we still found time to travel, and not just to Florida in the winter.

Our hotel conventions allowed us to mix business with pleasure. We went to many interesting cities, including Memphis, Nashville, New Orleans a dozen times, Montreal and Quebec in Canada—I can't even think of them all. We became such good friends with the manager at the Hotel Monteleone in New Orleans that he came to the Greystone to stay with us.

We both loved the Biltmore House in Asheville, North Carolina. I went three or four times a year. Dick often went with me. I especially love the gardens. I had to go once in the spring when the jonquils were in bloom, in June to see the roses and at Christmas to see the decorations, and then there was sometimes an extra trip with family, friends or hotel guests.

We took a lot of fishing trips, always with at least one other couple. In the 1950s, fourteen of us met in California to go on a four-day trip up the Rogue River into Oregon. We were fishing for steelheads (a type of rainbow trout). Park superintendent Fred Overly and his wife, Esther, and Ava and Lloyd Cline, who worked for us at the Greystone, were among the group. Dick and I and another couple drove. The others flew out. (Dick would not fly anywhere—ever.)

I don't know which was better—Zane Grey's cabin on the shore of the Rogue or the fact that I caught the biggest fish of the trip. Remember how I loved Zane Grey books? What I didn't know was

Four-day fishing trip, Rogue River, Oregon. *From left to right*: Dick, me and Ava and Lloyd Cline, who worked for us at the Greystone. *Martha Whaley's collection.*

how much he loved fishing. His son said he fished three hundred days a year in his adult life.

Much of our travel was sports related. We were both big UT Vols (University of Tennessee Volunteers) fans. If the football team earned its way to a bowl game, Dick and I were there, wherever "there" was.

We went to bowl games in New Orleans and several in Miami. Two years in a row, 1950 and 1951, the UT Vols, coached by Robert Neyland, played the University of Texas, coached by Darrell Royal, in the Cotton Bowl. In 1950, we went by train; UT won big. In '51, four or five carloads of us drove out; UT lost big. We decided we would salvage the trip and go on into Mexico. Dick didn't know a word of Spanish, but he looked at the menu and ordered the thing that had the longest name, thinking that it would be something big and special. He got a little saucer with two dried prunes; he didn't even like prunes. This time, the laugh was on the funny man.

Dick did take a cruise with me to the Caribbean, but cruising was not his forte either. He just preferred to have his feet on solid ground,

Yes, Dick did go with me on this Caribbean cruise—a rare occurrence. *Martha Whaley's collection.*

preferably American solid ground, or to be behind the wheel of a car, where he was in control.

Unlike Dick, I was never afraid to fly, though I don't like the taking off part. I had often flown to Arlington, Virginia, to visit Johnnie and Otto.

I didn't have much schooling, but I wanted to know how the other half lived. So in 1969, I went with friends on my first trip abroad—a tour to London, Holland, Paris and Rome.

What I remember most about London is that drinks had no ice. Later, I would learn that is true of all European and Asian countries. The clean part of London was spick-and-span, and the city had the most beautiful flowers at every house and cottage—baskets outside windows. Even little shacks had flowers. And there were no screens on the windows, and they had no flies.

Then we got to Holland, where we went to a restaurant called Five Flies, and guess what? They had a fly, the first fly I had seen in two weeks. Everywhere, things were screened in there.

In Paris, we took a trip on the Seine. It was lovely, but the weather was hot. When we got back, the men ordered beer. They said, "It's hotter than fire; who wants hot beer?"

Four of us got separated from the group. We were really lost; we had no idea where our hotel was. Suddenly, we looked over at the street, and there went our bus. Someone on the bus saw us. The bus stopped and picked us up. There is a sharp learning curve when you travel abroad. What I had learned was never to leave the hotel without the hotel card in my purse.

My next trip was to Norway, Sweden, Finland and Russia. I have lots of fun memories from that trip. First, my friend Reba Hicks set off the alarm going through security in Washington, D.C. When they opened her suitcase, they found a mousetrap, a knife and some cheese. When they questioned her about it, she said: "The last trip I was on, I had a mouse in my room. It nearly drove me crazy. I decided that wasn't going to happen on this trip." They let her take it all with her! Of course, that was pre-9/11.

When we got to Europe, another friend had no luggage. She bought a few things. She said, "You girls don't know what you're going to wear tonight, but I do." She never did get her luggage, so she wore my clothes the entire trip—shoes, panties, clothes, everything.

When we got to Russia, we were all a little nervous. Those were the Cold War days. Relations between the United States and Russia were not good at all. When Reba turned back the sheets in our hotel room, she said, "Do you reckon these are bugged?"

At our first dinner in Russia, Bruce Whaley asked for vodka. It didn't come and didn't come. Near the end of the meal, still having nothing

to drink, he reached for the pitcher on the table to pour himself a glass of water…it was vodka. It had been there all along. We just didn't think about them serving it by the pitcher.

Somewhere in Russia, we had stopped to look at fountains. There must have been one thousand buses in the parking lot. Reba wandered away and got lost. After awhile, she reappeared accompanied by a hippie—long hair, beard, the whole nine yards. "He was gonna help me hunt for ya'll," she said casually. Clearly, she had some things to learn about being safe in a foreign country, but she was unruffled by the experience. And as you can see, some of my most fun travel memories involve Reba. She was a great traveling companion and dear friend.

My next trip abroad was to China and Japan. I traveled with Gretchen Postlewaite. We had to have all kinds of shots, including yellow fever.

In China, for reasons I never did understand, we went where they were having a funeral. The room was very dim. I didn't see a corpse. I have no idea why we went there.

In Japan, I had a friend who liked a toddy before dinner. We set out to find a liquor store. We couldn't read any of the signs because of the Japanese characters instead of letters. We went into a bank, a church, a restaurant and a number of other buildings before we finally found a liquor store. Japan was unbelievably clean.

En route home from Japan, we had a stopover in Hawaii. I was convinced that I had to see more. So the next year, I went just to Hawaii for two weeks.

That was my favorite trip outside the continental United States. We stayed two weeks on Oahu, the main island, and did island hopping in little planes to the other islands. The flowers were exquisite. It rained sometime every day, which I am sure is why everything there is so lush and green. We had a wonderful luau on Maui.

My last foreign trip was in 1979 aboard the *Queen Elizabeth II* from Florida through the Panama Canal to San Diego. We had a storm, and I got seasick. That was horrible because I didn't get over it until I was back on land.

I tried to do an Alaskan cruise, but I never could get it worked out. My traveling days are over. It's just too complicated; I require too many pills and too much paraphernalia. I would love to have traveled to Scotland and Ireland. I wanted to see the heather and the border collies herding sheep.

I have been blessed to see and do many, many things. My travels afar are finished. But that's all right because I'd rather be here than anywhere I've ever been.

Martha and I became neighbors in 1992. I bought a condo in the same building where Martha lived. Right away, we were friends and lunch buddies. She is always happy to lend me a recipe, a cup of sugar or an egg. We have taken many mile-long walks together, eight loops around our parking lot, before meeting friends for lunch.

On warm afternoons, we sit outside together on the breezeway just to talk. We discuss her recipes and cooking, her flower garden or whatever ballgames are in season. Both of us have flowers that have been given to us that we have had planted on the bank outside our condo building. We enjoy not only the beauty of the plants but also reminiscing about the family and friends who gave them to us. We talk about family activities, church, old times and whatever else strikes our fancy at the moment. Whenever I can't remember a name or an event, I just ask Martha. She never lets me down—she remembers.

When my husband, Dillard, lost his vision, Martha drove him places if I had other appointments. He liked to brag to people that he had a ninety-seven-year-old woman driving him around. Once, when he was telling this to several people at the crafts fair, Martha and I walked up, and I asked, "Are you ready to go?" They thought I was his ninety-seven-year-old driver. Martha had a good laugh—I was only seventy-two.

Martha's enthusiasm for life and her thoughtfulness of others are an inspiration to me. It is good to have her as my friend.

Frances Mynatt

I love my flowers, many given to me by friends and family over the past thirty-plus years. *Courtesy of Genie Brabham.*

Chapter 16

On Gardening

I inherited my dad's love of digging in the dirt, and until my fall in August 2012, I was right out there in the dirt, doing just that. (A broken leg and a broken left arm have slowed me down.) There is a little walkway leading into my condo that goes over a steep bank. I have landscaped that bank one plant at a time.

My friends and family say I can make anything grow. I have huge, healthy hostas with different patterns, calla lilies, roses, brown-eyed Susans, azaleas, hydrangeas, daylilies, chrysanthemums—oh, and lots more.

Many of them were gifts. If it comes in a pot and has roots, I am going to set it out, fertilize it and watch it grow. It gives me and my neighbors a lot of pleasure.

I was also renowned for my tomatoes. I planted several varieties, and I had enough to eat all I wanted and to share with everyone I knew. This year, I cannot navigate the steep bank, so I did not set out tomatoes, but the flowers, all of which are perennials, are gorgeous. Nino, our maintenance and grounds man, has helped me do the things I cannot manage on my own. He doesn't speak much English, and I don't speak any Spanish, but I do a lot of pointing. He does a lot of nodding, and we manage to get things accomplished.

My son, Bob, also inherited the passion for digging in the dirt. He had a great gift for landscaping. When First Baptist Church built its new building out on Highway 321, the bid they got for landscaping was $60,000. Bob volunteered to do it, and it only cost the church $12,000. That's my boy.

On a visit to the Biltmore House years ago, I saw a double dogwood. I had never seen one before. I mentioned it to Bob, and he got me one. It's been outside my condo for twenty-five years. It's so tall now you have to be way back from it to see the blooms. All I had to do was mention something I wanted, and Bob got it for me. The dogwood tree is just one example. It is a constant reminder of my precious son who died of a brain tumor in 2003.

I also grow inside plants. I cannot even begin to guess how many African violets I have grown, divided, rooted and given to the Garden Club for their annual plant sale, as well as to friends. I love my Christmas cactus and orchids, too. They're beautiful, and they are very satisfactory. They are not high maintenance, and they don't make a mess like so many indoor plants.

I love anything that blooms, but I suppose if I had to pick a favorite flower, it would be the rose—there are so many kinds and colors.

It has been my great joy to know Martha since 1984, when my husband, Ed, and I moved to Gatlinburg to be near my mother, who required our care. I am forever thankful that my mother told Mary Connor and Claire Loomis that I played bridge, so they, in turn, invited me to join their bridge club, Martha's bridge club. My dear friend, Nancy Whaley Cooper, Martha's sister-in-law, was also in it. We met every other Thursday.

I remember the first time we played at Martha's condo because she had gorgeous African violets on her sun porch, and I love African violets. I played in the "Thursday Club" for ten years, but I dropped out because Ed and I were spending seven months a year in Florida.

After Ed retired, we started our own "Tuesday Club." It was just Nancy, Martha, Ed and me. We played every Tuesday. The person at whose house we were playing chose a place for us to go eat lunch. Ed always drove us all. Ed's and my favorite place to lunch was the Wild Plum on Buckhorn Road. Martha played in both bridge clubs.

One of Martha's favorite expressions is: "I love you to pieces." Ed, who adored Martha, quickly adopted her expression, saying, "I just love Martha to pieces." They shared the same birthday, April 1, but Ed would never tell anyone when he was born because he didn't like to be teased

The Tuesday Bridge Club. *From left to right:* Ed Collins, Sara Collins, Nance Cooper and me—waiting to eat at the Wild Plum, June 2009. *Courtesy of Sara Collins.*

about being an April fool. However, when he found that Martha shared his day, he decided it was okay for folks to know.

Ed died on a Tuesday, September 6, 2011. I was back in church the following Sunday. I felt so lost and alone, but Frances Mynatt invited me to join a group that included Martha that regularly lunched at the Little House of Pancakes following church each Sunday. I went, and I have been going ever since.

Martha is so good for me. She is always fun, always positive. She is a joy to be with. She's just a special person to me; she is one of my favorite people. I love her to pieces!

Sara Collins

Other Hobbies

S ome of my hobbies have come and gone with the times, though most of them I stuck with for twenty years or so. Fishing, for example, was a pastime I shared with Dick. Knitting was something I did during World War II to help the war effort. But others, like gardening and bridge, have been constants over the years.

I have made pillows with fancy stitching that I don't even remember how to do any more. I still have one on my sofa. I have made button necklaces for myself and as gifts.

When Johnnie came to visit me in Venice, Florida, in the 1970s, we took macramé classes and made all kinds of plant hangers and such. Some of you will remember the macramé craze.

I took ceramics classes with Johnnie in Venice and in Pigeon Forge and then out in Cosby. In Cosby, they had teachers come from other places, from as far away as New York. They gave me pieces of green ware, already molded. Then I painted it, and they fired it. That was one of my two-decade hobbies. I gave most of what I made away as gifts, but I still have two pieces I am very attached to: a dish of iris and a white swan.

I told Dick when I started drawing Social Security that I was going to put every bit of it into green ware, but I didn't really do that. Incidentally, I might add that Social Security has invested a lot of money in me. I'm sure they're glad everyone doesn't live to be my age; the system would already be bankrupt.

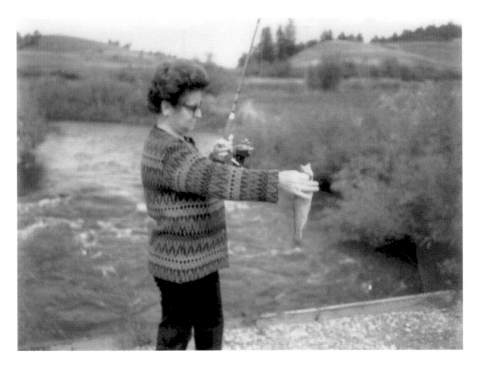

Another fishing adventure—showing off my catch. Big Spring Fork, Montana, September 1968. *Martha Whaley's collection.*

And then there's bridge. I have played bridge for decades—at least five, maybe six. I learned to play after I was married. I only gave it up last summer because too many members of my bridge club had died or just weren't able to get out any more. Can you believe that when I started playing bridge, ladies wore hats and gloves to bridge club? Antoinette Ogle and I organized the bridge club.

I knew Antoinette all her life. I was thirteen when she was born. We organized the bridge club, and it survived for forty years. Even though Antoinette suffered from multiple sclerosis for years, she hired two ladies who prepared a fabulous lunch for us every time Antoinette was the hostess. She really spoiled us. She gave us Christmas gifts and bought us tickets to the Easter Parade, the proceeds from which benefited charity. Antoinette was such a good woman.

When it was my turn to host the club, they wanted me to make coconut cake. I preferred to make pies instead of cakes, and I still do, but I did it for "the girls."

On one of our interview days, I said to Martha, "Think about all the things that have changed in your lifetime..." She interrupted and said with a chuckle, "Everything."

If you are interested in just how accurate that one-word answer is, take a quick look at the list at the end of the next chapter. The Wright Brothers flew in 1908, and Henry Ford invented the Model T in 1909, but beyond that, virtually everything I can think of (and some things that I would never have thought of) has been invented since 1910.

Note that two of the things Martha has specifically mentioned in her recollections—the zipper and the crossword puzzle—both came into existence in 1913. She was fascinated to learn that trivia tidbit.

What I was really trying to get at was which of the things that have been invented in her lifetime has had the most impact on her personally. So I reframed the question, and the answer I got was just as immediate as the "everything" answer. You may be surprised. Read on...

Since I Was Born

I have never spent a lot of time reflecting on what has come into existence since I was born. But I guess it would be safe to say that almost everything I have and use now did not exist in 1910. I am not at all personally interested in technology. I do not have a cellphone. I have never owned a computer. I don't understand a thing about them. If it has more than one button, I can't operate it.

But it's easy for me to say what invention is the most important to me personally: that's the television. Why, you might ask? Well, I have always enjoyed television. I used to have lots of favorite shows when TV was fairly new on the scene. I watched *The Lawrence Welk Show* every Saturday night. Bob and Sissy could do any kind of dance. And I loved Norma Zimmer, the "Champagne Lady." She had a beautiful voice; she just died a couple years ago. I loved the band. I watch it now in reruns—still on Saturday nights at seven o'clock.

I also liked *Sing Along with Mitch*, but that's not on in reruns. The words were printed on the screen, and a little white dot bounced from word to word, so everyone could sing along. It was great fun.

I loved *The George Burns and Gracie Allen Show* with George Burns and Gracie Allen and *The Jackie Gleason Show* with the Honeymooners skits and the June Taylor Dancers. *The Red Skelton Show* was right up there on my list of favorites. Red Skelton doing the Joe the Bartender skits could make even the most down-and-out person laugh. And I couldn't leave *The Andy Griffith Show* off my list, but it was Don Knotts as Barney Fife who was my favorite, not Andy.

The sheer entertainment value of television was much greater to me in the 1950s to 1980s, when there were family shows, wholesome sitcoms and great variety shows. I do not like all the reality TV that is on now.

But I do still enjoy watching *Wheel of Fortune* and *Jeopardy!* every evening. Both those shows engage and stimulate my brain. That's the same reason I liked crossword puzzles.

And folks who know me will tell you the other reason I like TV is because I can watch sports, lots and lots of sports. I watch all the pro football games and most of the college games. I follow UT sports—Vols football, girls' and boys' basketball, girls' softball and boys' baseball.

Dick and I always had season tickets to the UT Vols football games until he got so he couldn't make it to our seats in the stadium anymore. (In his last years, he had to walk with a walker following surgery to remove a tumor around his spine.)

Peyton Manning is my favorite athlete. I never miss a Peyton Manning game. I loved him when he was the UT quarterback. Then I watched all the Indianapolis Colts games when he went there. I wish he had quit after he got hurt and gone home to enjoy his family and fortune. But he seems to know what he's doing, and I'm there to watch him in every Denver Broncos game. I am sad he didn't get that Super Bowl victory this year [2013].

I also follow the Atlanta Braves faithfully, but I've gotten upset lately because they've traded a lot of the players. I'd watched them so long that I felt like I knew them. They were like family.

My Saturday afternoons and Sunday afternoons are organized around what games are being televised and when. I go to church and out to eat lunch at the Little House of Pancakes, but if there is a one o'clock game, I don't dilly-dally.

Even though I am getting hard of hearing and my vision isn't what it used to be, I have a nice big, flat-screen TV, and I can turn the volume up as loud as I want. So the TV still brings me a lot of pleasure.

I will confess that no one really wants to watch TV with me because I have the volume turned up so loud. It's okay, though, because I am so engrossed in the game, I would hardly know if anyone were in the room with me or not. Sometimes my friend Frances, who lives upstairs, watches on her TV and I watch on mine, but we talk on the telephone about what's going on as it is happening.

WHAT'S NEW IN MARTHA'S LIFETIME?
1910–1999 INVENTIONS

1910	talking motion picture
1911	auto-electrical engineering ignition system
1912	motorized movie camera, the tank, Life Savers candy, shopping bag
1913	crossword puzzle, bra, Erector Set, mass production, modern zipper
1914	TinkerToy sets
1915	Pyrex
1916	radio tuners, stainless steel, Lincoln Logs
1918	fortune cookies, superheterodyne radio circuit (used in all radios and TVs today)
1919	pop-up toaster, short-wave radio
1920	Band-Aids, hair dryer
1921	first robot, Wheaties, Wonder Bread, lie detector
1922	insulin, first 3-D movie released
1923	traffic signal, television (iconoscope), self-winding watch
1924	loudspeaker, notebooks with spiral bindings
1925	masking tape, mechanical TV
1926	PEZ candy, first analog crystal watch
1927	first electric shaver (Schick), first complete electronic TV system, technicolor, aerosol can, iron lung
1928	penicillin, bubble gum
1929	car radio, sunglasses, yo-yo
1930	Scotch tape patented, frozen food patented by Birds Eye, neoprene, analog computer, Toll House cookies
1931	stop-action photography
1932	Polaroid photography, zoom lens and light meter, parking meter

1933	FM radio, stereo records, prototype drive-in movie theater
1935	nylon, canned beer, radar patented, Monopoly, trampoline, ballpoint pen
1936	voice recognition machine
1937	photocopier, shopping cart, jet engine
1938	nylon stockings, strobe light, LSD synthesized, Teflon, Nescafé
1939	helicopter, electron microscope
1940	color TV system, the jeep, blood bank
1941	first computer-controlled software, neutron reactor
1942	first electronic digital computer, turboprop engine designed, duct tape
1943	synthetic rubber, Silly Putty, aqualung
1944	kidney dialysis machine, synthetic cortisone, Clue board game
1945	atomic bomb, microwave oven, Slinky, Tupperware
1946	bikini, disposable diapers
1947	holography, transistor, kitty litter
1948	Velcro, Wurlitzer jukebox, Scrabble
1949	cake mix, Lego
1950	first credit card (Diners), Frisbee, *Peanuts* comic strip
1951	Super Glue, power steering, video tape recorder
1952	Mr. Potato Head, bar code, diet soft drink, hydrogen bomb
1953	radial tires, music synthesizer, black box, transistor radio
1954	oral contraceptives, nonstick Teflon pan, solar cell, McDonald's
1955	tetracycline, optic fiber
1956	computer hard disk, hovercraft, Mistake Out (later renamed Liquid Paper), TV remote control, Scotchgard, Yahtzee
1957	Fortran computer language
1958	computer modem, laser, Hula Hoop, integrated circuit
1959	Barbie doll, internal pacemaker, microchip
1960	halogen lamp, Etch A Sketch

1961	Valium, nondairy creamer
1962	audiocassette, fiber-tip pen, Spacewar! (first computer video game), silicone breast implants
1963	videodisk, Lava Lamp
1964	acrylic paint, permanent-press fabric, Smiley Face, BASIC
1965	Astroturf, soft contact lenses, NutraSweet, compact disk, Kevlar
1966	electronic fuel injection for cars
1968	computer mouse, computer with integrated circuits, RAM
1969	Arpanet (first Internet), artificial heart, automated teller machine (ATM)
1970	daisy wheel printer, floppy disk
1971	dot matrix printer, food processor, LCD, microprocessor, VCR, karaoke machine
1972	word processor, Pong (first megahit video game), Hacky Sack
1973	gene splicing, Ethernet, Bic disposable lighter
1974	liposuction, Rubik's Cube
1975	laser printer, push-through tabs on drink cans
1977	magnetic resonance imaging
1978	VisiCalc spreadsheet computer program, successful artificial heart
1979	cellphones, Walkman, roller blades, Trivial Pursuit
1980	hepatitis B vaccine
1981	MS-DOS, IBM-PC
1982	genetically engineered human growth hormone
1983	Apple Lisa, soft bifocal contact lens, Cabbage Patch Kids
1984	CD-ROM, Apple Macintosh
1985	Microsoft's Windows program
1986	high-temperature superconductor, synthetic skin, disposable camera
1987	3-D video game, disposable contact lenses
1988	digital cellular phones, RU-486 abortion pill, Doppler radar, Prozac, genetically engineered animal, Indiglo nightlight

1989	high-definition TV
1990	World Wide Web, Internet protocol (HTTP), HTML
1991	digital answering machine
1993	Pentium processor, Beanie Babies
1994	HIV protease inhibitor
1995	Java computer language, DVD
1996	Web TV
1997	gas-powered fuel cell
1998	Viagra, Google

When I stand in the pulpit each Sunday, I can see almost everyone in our sanctuary at First Baptist Church, Gatlinburg, Tennessee. I can see who's participating and who's bored, who's happy to be there and who's wondering what to do for lunch. Almost every Sunday, I can see Martha Whaley, actively engaged in worship, singing most hymns from memory even into her 104th year.

Last fall, Martha celebrated her seventy-fifth year as a member of our church, which she joined in October 1938, as a young wife and mother. Weekly attendance was the norm for her family as the decades passed. Martha sang in the choir; she taught children's Sunday School. First Baptist was a regular part of her life. Twice each year, she appeared at church with two large metal popcorn tins, repurposed as cookie jars. One was filled with chocolate chip cookies, the other with white chocolate macadamia nut cookies, all homemade. She brought them for Vacation Bible School and for our annual ministry project to the Gatlinburg Craftsmen's Fair.

When others in our church failed to volunteer or suggested that they no longer could fill a need in the church, I thought of Martha and her steadfast commitment to both worship and to work. "If Martha can continue to make her homemade cookies, well into her nineties," I would challenge others, "what skills can you use to serve?" At 102, she held a cooking class for some of our teenage girls so that the legacy of her homemade cookies could continue long after she has left our family of faith.

During my sixteen years as minister of education, I was privileged to have five women who were still members of our church at 100 years old. Martha is the most active and eager of them all, still going strong at 103. These mountains make strong women.

Gina Brown

On Faith and Religion

You know already that learning Bible verses, reading the Bible and attending church were important in my life. From the minute I was born, my parents and Granny instilled in me a love of God and trust in Him.

My favorite books of the Bible are Ephesians, though I don't understand it all, and the Book of Psalms because those passages bring me so much promise and comfort. Psalm 23 is my favorite of them all: "The Lord is my shepherd. I shall not want." That has certainly been true in my life.

I have always attended church. We used to wear hats and gloves. I am not sad that went out of fashion. Now many ladies wear pants to church. I don't have a problem with that, but I still put on a dress to go to church. It's just what feels right for me. That's ironic, though, because I was thrilled when women started wearing pants. I said, "You'll never get me back in a dress." But I do don one once a week—for church.

I have found various ways to be actively involved in my church. October 2013 marked my seventy-fifth year as a member of First Baptist Church, Gatlinburg. Johnnie and I used to sing in the choir, even though I never thought I had a very good singing voice.

For twenty years, Blanche "Boots" Huff and I chaired the social committee. Everyone brought a dish for church dinners. Boots and I used to say Baptists were the hungriest people there were because we were all the time feeding them.

Now, brothers Ron and Don Smith do all the cooking for the Wednesday night suppers. Others help with food preparation, table setup

and serving. We have a beautiful commercial kitchen that Hattie Ogle gave the church when it moved to its new location.

Henrietta Huff and I worked with three- and four-year-olds in Vacation Bible School for fifteen or twenty years. It lasted until noon, Monday through Friday. When I felt I was too old to teach the children, I started baking cookies for the VBS snack time—twelve to fifteen dozen chocolate chip and white chocolate macadamia nut cookies. I make two popcorn tins full. The cost of macadamia nuts has become almost prohibitive, but I just can't give up the tradition. (I do the big cookie-baking two other times each year—once for the vendors at the annual Craftsmen's Fair and then at Christmas for family and friends.)

I tell all my grandchildren to keep their children in church. They need to learn what's good for them.

If I cannot attend church, I enjoy watching church services on television. I have always loved Billy Graham; he has had a wonderful ministry to people all over the world. I listened to Dr. Robert Schuller on the *Hour of Power*. Now his grandson has taken over; he's Robert, too.

I find Christian music uplifting. I don't get much out of contemporary Christian music. It seems like the louder they scream, the better it is. The Shadow Mountain programs on the Trinity Broadcasting Network out of California have awfully good music. But my favorites are still the oldies like "Amazing Grace," "The Old Rugged Cross" and "How Great Thou Art."

My faith has helped me through a lot of loss. I have lived so long that I have outlived many family members and friends. A friend once asked how I coped with the loss of so many people who were dear to me.

"I just keep surrounding myself with youngsters like you," I replied.

The friend, who was sixty-three at the time, said, "No one has called me a youngster in forty years."

"Well, you are almost forty years younger than I am. Everything is relative."

I don't mean for that to sound callous or glib, but there is a lot of truth to it. Otherwise, I would be sitting home alone because everyone my age is dead and gone, has dementia or is in a nursing home. Though I am not as extroverted as Dick, I do love people. I just prefer a balance of people and privacy.

My ultimate prayer is that the good Lord will let me take care of myself as long as I am here. So far, so good.

And when my time on this earth is done, I don't want a funeral home service. I want to be brought back to First Baptist Church one last time. And it's okay if they dress me in black because black and white really are my favorite colors. Anything goes with black.

It has been my good fortune to be Martha's doctor for over thirty years. I have never had an older patient, but it is not her age that is so amazing to me. It is her generosity; she loves to give. She is a loving, giving, caring person.

I have often considered why Martha has lived so long and so well. She has always eaten healthily, lots of fresh vegetables and not a lot of meat, and she certainly has good genes. She keeps physically and mentally active. All of that is important, but I think what really keeps her going is her love for life, and she invests herself in trying to make life better for others.

I feel like Martha inspires and motivates everyone who knows her, including me. When I think of Martha, I think "vitality." She brings vitality to everything she does. We all could and should take lessons on life from her.

Paul Serrell, MD

It has been a pleasure to assist Dr. Serrell in caring for Ms. Martha. She has touched my life greatly.

Donna Morton, LPN

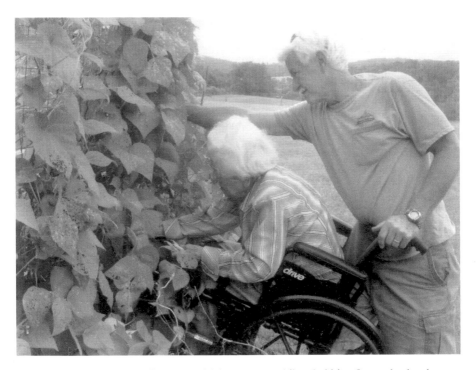

Son-in-law Bill finds a way for me to pick beans even while rehabbing from a broken leg, summer 2012. Oh, happy day! *Courtesy of Robin Whaley Andrews.*

On Aging

Until I had a fall at my daughter's house on August 29, 2012, I really didn't feel like I had slowed down much. I was still driving in my little three-mile radius of my condo to run my errands—bank, grocery store, beauty parlor, post office, church. I walked a mile every morning, eight laps around the parking lot at my condo; played bridge; and attended church every Sunday. I ate lunch out each day and cooked a little dinner each night. And I baked a lot of goodies for folks.

But my broken leg and arm required me to be in a rehabilitation center for four months. And then I was at my daughter's house for a while longer. That took the wind out of my sails. I haven't been able to get back to where I was before the fall, even though I did everything I was supposed to do in rehab. Oh, but my reputation for cooking followed me to rehab, too. Before I left, I baked them two chocolate meringue pies and cooked pork chops.

I was able to return to my condo, but I just can't seem to get the wobble out of my walk. I use a cane now, and I don't like how it slows me down. I'm used to being able to do what I want when I want. Now I am much more dependent on other folks because Robin won't let me drive anymore. My friends are wonderful about picking me up and taking me to lunch, church, the grocery store, wherever I need to go. Even though they assure me that it's no trouble, I would much prefer to be able to drive my car that's just sitting out in front of my condo going nowhere.

I'm still working at getting stronger, though. I can't just quit 'cause when you sit down and quit, that's it. My wonderful son-in-law, Bill, even found a way to get me out in his garden to pick beans while I was rehabbing. I hope I don't ever have to stop doing the things I love most.

Everyone knows there are disadvantages of growing old, but there are also advantages, you know? As I reflected on that thought for this book, here's what I decided: the advantages and the disadvantages for me are equal—three of each.

DISADVANTAGES

- I don't have as good health as I used to. I have Type 2 diabetes; and as I've said, I don't see or hear, taste or smell as well as I used to.
- I don't have anyone older than I am to call and ask what I've forgotten. I used to call my brothers.
- I don't know anyone I grew up with. They are all gone.

ADVANTAGES

- You learn as you go. I've always worked hard, but it hasn't hurt me, and I've learned something from each experience.
- Growing old is a lot of fun if you have good health.
- I have a purpose. The good Lord put me here for a reason. I must have a few more things I'm supposed to do because I'm still here keeping on keeping on. I think that's a blessing.

For ten years, I hung out with Martha Whaley, hoping to learn her secrets of longevity. When asked her secret, she always replied, "Hard work." Here are other things I learned from her through personal observation:

- Be humble.
- Laugh heartily.
- Live simply and eat sparingly.
- Be silent.
- Stay open-minded, not opinionated.
- Be generous—cook every day and give away that which you prepare and the vegetables that you grow.
- Love nature and grow flowers.
- Play cards.
- Follow all sports players, teams and events and stay up late to root for your favorites.
- Be loyal.
- Be kind.
- Be comfortable with yourself, with others and with silence.
- Walk a mile each day.
- Be courageous and never complain.
- Be curious and interested in current events. Follow the news.
- Never say anything unkind about anyone.
- Be punctual and dependable.
- Avoid controversy.
- Be upbeat, jolly and happy.
- Be warm and welcoming.
- Be flexible.
- Thank God for His goodness.

These are the be-attitudes that Martha Whaley's life of simplicity taught me. I hope I can be just like Martha Whaley when I grow up.

Karen Houck

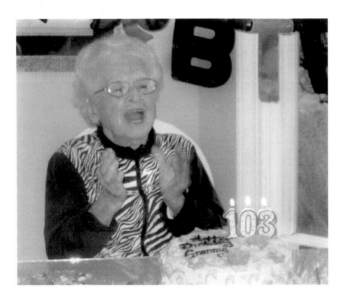

I am delighted to be celebrating birthday number 103. Can you tell? Daughter Robin really knows how to make me feel special. *Courtesy of Robin Whaley Andrews.*

Chapter 21

The Secret of My Longevity

My doctors think that part of the reason I have lived so long and am still so healthy is because I have always walked a lot—miles and miles a day in my youth—and a mile a day through year 102. And I have eaten mostly fruits and vegetables all my life, light on the meat.

When people ask my secret, I tell them there isn't any secret. It's as easy as the proverbial old 1-2-3:

- **Stay busy.** Busy people are happy people. If you are sitting around doing nothing, you usually get in trouble for doing the wrong thing.
- **Stay interested in what's going on around you.**
- **Go to church.**

My dad, Bruce, and Martha's husband, Dick, were brothers, so that makes Martha my aunt by marriage. She is very important in my life, especially where work is concerned. I manage buildings for the Whaley Family Partnership on the parkway in Gatlinburg. I often have questions, many of which I direct to Aunt Martha because she has a firm grasp on reality, and I value her opinion.

I remember once when a man wanted to rent one of our larger shops for a handsome monthly rent, but I had doubts about what I should do, so I went to Aunt Martha with my problem. She listened attentively while I explained, and she thought it over for a bit. Then she looked at me and told me that I should do it. Problem solved.

Aunt Martha is a wise and grand lady, and we all treasure her.

Stephen Whaley

Words of Wisdom

I don't think I have all the answers, but I do have the benefit of having lived for over ten decades. Since it is true that you learn as you go, I can say I've gone a long way and learned a whole lot. Like everyone else, I have learned from my parents, my teachers and from life itself. I've just been at it longer than most folks.

If I can bequeath some of the wisdom of age to the young, I would share these simple thoughts:

Love everyone. The Good Book says: "Love one another" (John 13:34). In Sunday School, children learn the Golden Rule. It doesn't get any simpler than that: "Do unto others as you would have them do unto you" (Matthew 7:12). What a wonderful world it would be if we could all just like one another. People fight all the time; it's just awful. I hate to turn on the news because that's just about all they show.

Work hard. Don't think the world owes you a living. If you don't do anything but wash dishes, you learn and grow.

Learn from your mistakes. Sometimes you learn the hard way, but that's good, too. We got my oldest granddaughter a car. She was so upset when she got a ticket for speeding. I told her that there would be bumps in the road. It's just important to learn from your mistakes and keep on going. Life's not always going to be smooth sailing.

Look around you and remember: "This is the day the Lord has made. We will rejoice, and be glad in it" (Psalm 118:24). Don't be consumed with worry or regret. Live the day you have right now. It's a gift from the good Lord.

Epilogue

*A*s I interviewed Martha, it quickly became apparent that one common thread that runs through her life is her cooking. She baked her first cake for her beloved Pi Phi teachers at the Sugarlands School. She started cooking for her family when she was nine because her mother was sick. She went to stay with her sister Nora when the twins were born so that she could cook for the family.

Her first job outside her home was to work in the dining room at the Mountain View Hotel and then to cook for the teachers and students at the Settlement School.

When she got married, she ran the dining room and cooked first at the Riverside Hotel and then at the Hotel Greystone. She organized church suppers for twenty years. She's baked cookies for Vacation Bible School for twenty-five years.

Cooking is more than a job. It is how Martha shares herself. It's a talent and a gift. For those of you who have been fortunate enough to know Martha personally, you are indeed blessed. For those of you who are fortunate enough to have eaten her fine cooking, your palates and your stomachs are indeed blessed.

Some people send cards or flowers, write notes or letters, make phone calls, send e-mails or text messages. Martha cooks. It's how she shows her love, her caring, her concern, her gratitude. It is how she's says, "I love you," "Thank you," "I appreciate you," "I share your sorrow," "I'm sorry you are sick," "I hope you feel better," "I'm thinking about you," "I'm glad we could be together to celebrate this special occasion."

The first time I was to interview her, we had to postpone our meeting because she had not finished baking her fifteen dozen cookies for Vacation Bible School. Secretly, I hoped she had saved one chocolate chip cookie and one white chocolate

macadamia nut cookie for me. (I had the good fortune to sample them once at a picnic.) Alas, she had sent them all in tins to the church. I teased her about getting them out of the house before I could get into them.

The next time I came to interview Martha, she had made a batch of Lemon Snowdrops just for me. They were divine; that's our Martha.

Many of you will never meet Martha or be able to sample a slice of her lemon meringue pie or a serving of her scrumptious green beans. For you, I have included some of her most-requested recipes. Try one. This is how you can be part of Martha's life and share her talent for cooking. Just remember that she would want you to fold in love and share her recipe with someone in your life—family, friends, a new neighbor. That's what Martha would do.

Appendix

Martha Whaley's Most-Requested Recipes

INDEX

Martha Whaley's Chocolate Chip Cookies

2 cups butter
2 cups granulated sugar
2 cups brown sugar
4 eggs
2 teaspoons vanilla
4 cups flour
5 cups oats
1 teaspoon salt
2 teaspoons baking soda
2 teaspoons baking powder
24 ounces chocolate chips
8 ounces Hershey bars, grated
3 cups chopped nuts

Preheat oven to 375 degrees.

Cream butter and sugars. Add eggs and vanilla. Mix together flour, oats, salt, baking soda and baking powder. Combine wet and dry ingredients.

Add chocolate chips, grated chocolate and nuts.

Place golf ball–sized cookies 2 inches apart on an ungreased cookie sheet. Bake for 6 to 10 minutes at 375 degrees. Do NOT overbake.

Note: *Recipe makes a LOT of cookies—enough to fill a large popcorn tin. It may be cut in half for a manageable-sized batch. Be sure to place cookies 2 inches apart.*

Martha Whaley's White Chocolate Macadamia Nut Cookies

Yield: Approximately 4 dozen

1 cup uncooked quick-cooking oats
¾ cup all-purpose flour
½ cup light brown sugar
½ cup butter or margarine, softened
¼ cup sugar
1 egg
½ teaspoon salt
½ teaspoon vanilla
½ teaspoon baking powder
½ cup macadamia nuts (whole or pieces)
6 ounces white chocolate in small chunks or 6 ounces white
 chocolate morsels (Nestlé)

Preheat oven to 375 degrees.

Mix all ingredients except nuts and white chocolate with electric mixer at medium speed. Scrape bowl occasionally. Continue mixing until well blended. Fold in macadamia nuts and white chocolate pieces.

Spray cookie sheets lightly with vegetable oil. Drop batter by teaspoonfuls 2 inches apart.

Bake 10 to 12 minutes or until lightly browned. Let cool for 5 minutes. Transfer to a wire rack to finish cooling.

Martha Whaley's Lemon Snowdrops

Adapted from Betty Crocker Cooky Book *(General Mills, Inc., 1963)*
Yield: 5 dozen double cookies

1 cup butter or margarine, softened
½ cup sifted confectioners' sugar, plus extra for rolling
1 teaspoon lemon extract
2 cups Gold Medal all-purpose flour, sifted (if self-rising flour is used, omit salt)
¼ teaspoon salt

Preheat oven to 400 degrees.

Cream butter and sugar. Add lemon extract, flour and salt; mix well.

Measure level teaspoonfuls of dough; round into balls and flatten slightly. Place about 1 inch apart on an ungreased baking sheet.

Bake 8 to 10 minutes or until very lightly browned. Cool. Put together with filling (see below). Roll in confectioners' sugar.

LEMON FILLING
1 egg, slightly beaten
Zest of 1 lemon, grated
⅔ cup sugar
3 tablespoons lemon juice
1½ tablespoons butter, softened

Blend egg, lemon zest, sugar, lemon juice and butter in top of a double boiler. Cook over hot water until thick, stirring constantly. Set aside to cool.

Martha Whaley's Old-Fashioned Apple Stack Cake

2 cups sugar
1 cup butter
2 eggs
6 cups flour (plain)
1 teaspoon baking soda
3 teaspoons baking powder
½ cup buttermilk
1 teaspoon vanilla

Preheat oven to 400 degrees.

Cream sugar and butter together. Add eggs, one at a time, beating well after each addition.

Measure flour and sift with other dry ingredients; add to batter, alternating with buttermilk and vanilla.

Divide into 6 or 8 parts. Use a well-floured board to roll out mixture or pat into well-greased 9-inch pans. Bake at 400 degrees until nice and brown.

APPLE FILLING
1 pound dried apples
1 cup brown sugar
1½ teaspoons cinnamon
½ teaspoon cloves
½ teaspoon allspice

Cook apples and mash thoroughly. Add sugar and spices. Cool before spreading between the layers.

Martha Whaley's Lemon Meringue Pie

Adapted from Better Homes and Gardens New Cook Book
(Meredith Press, 1968)

FILLING:
 1½ cups sugar
 3 tablespoons cornstarch
 3 tablespoons all-purpose flour
 Dash of salt
 1½ cups hot water
 3 egg yolks, slightly beaten
 2 tablespoons butter or margarine
 ½ teaspoon grated lemon peel (the zest of one whole lemon
 makes it better!)
 ⅓ cup lemon juice
 1 (9-inch) pie crust
 Meringue (see recipe opposite)

Preheat oven to 350 degrees.

In saucepan, mix sugar, cornstarch, flour and salt. Gradually add hot water, stirring occasionally. Cook and stir over high heat until mixture comes to boiling. Reduce heat; cook and stir 2 minutes longer. Remove from heat.

Stir a small amount of hot mixture into egg yolks and then return to hot mixture. Bring to boiling and cook for 2 minutes, stirring constantly. Add butter and lemon peel. Slowly add lemon juice, mixing well. Pour into pastry shell.

Spread meringue (see recipe on page 159) over filling; seal to edge. Bake at 350 degrees for 12 to 15 minutes. Cool before cutting.

Note: *I use 1½ of the filling recipe to fill my 9½-inch pie plate, which is also deeper than the normal pie plate.*

Meringue (for a 9-Inch Pie)

3 egg whites
½ teaspoon vanilla
¼ teaspoon cream of tartar
6 tablespoons sugar

Beat egg whites with vanilla and cream of tartar until soft peaks form. Gradually add sugar, beating until stiff and glossy peaks form and all sugar is dissolved. Spread meringue over hot filling, sealing to edges of pastry.

Martha Whaley's Cream Pie Variations: Coconut and Chocolate

Martha Whaley's adaptations of the vanilla cream pie recipe from Better Homes and Gardens New Cook Book *(Meredith Press, 1968)*

¾ cup sugar
⅓ cup all-purpose flour or 3 tablespoons cornstarch
¼ teaspoon salt
2 cups milk
3 egg yolks, slightly beaten
2 tablespoons butter
1 teaspoon vanilla
1 (9-inch) pie shell
Meringue (see recipe on page 159)

Preheat oven to 350 degrees.

In a saucepan, combine sugar, flour and salt; gradually stir in milk. Cook and stir over medium heat until bubbly. Cook and stir for 2 minutes. Remove from heat.

Stir a small amount of hot mixture into yolks; immediately return to the hot mixture and cook for 2 minutes, stirring constantly. Remove from heat. Add butter and vanilla.

Pour into a baked, cooled pie shell. Spread meringue (recipe on page 159) on top of pie and bake at 350 degrees for 12 to 15 minutes or until meringue is golden. Cool.

Coconut Cream Pie

Add 1 cup flaked coconut to Vanilla Cream Pie filling. Top with meringue; sprinkle with ⅓ cup coconut flakes.

• •

Chocolate Cream Pie

When preparing Vanilla Cream Pie filling, increase sugar to 1 cup. Chop two 1-ounce squares unsweetened chocolate and add with milk. Top with meringue and bake as directed.

Plain Pastry

Adapted from Better Homes and Gardens New Cook Book
(Meredith Press, 1968)

Yield: 1 single pie crust, 8, 9 or 10 inches

*1½ cups sifted, all-purpose flour (Martha's preference:
Gold Medal flour)*
½ teaspoon salt
½ cup shortening
4 to 5 tablespoons cold water

FOR ONE 8-, 9- OR 10-INCH DOUBLE CRUST OR LATTICE TOP OR
TWO 8-, 9- OR 10-INCH SINGLE CRUSTS:
2 cups sifted all-purpose flour
1 teaspoon salt
⅔ cup shortening
5 to 7 tablespoons cold water

Preheat oven to 450 degrees.

Sift flour and salt together; cut in shortening with a pastry blender until pieces are the size of peas. Sprinkle with 1 tablespoon water. Gently toss with a fork and push to the side of the bowl. Repeat, adding water 1 tablespoon at a time until all the flour is moistened. Form into a ball. Flatten on a lightly floured surface by pressing with the edge of hand three times across in both directions. Roll from the center to the edge until ⅛-inch thick.

Put in a pie plate. Trim to ½ to 1 inch beyond the edge. Fold under and flute the edge. Prick the bottom of the pastry and 2 or 3 times around the sides. Put parchment paper over crust; place pie weights in crust. Bake at 450 degrees for 10 to 12 minutes or until golden.

Martha Whaley's Pecan Balls

Yield: 4 dozen

1 cup butter, softened
½ cup powdered sugar, sifted, plus extra for rolling balls
1 teaspoon vanilla
2¼ cups all purpose flour
¼ teaspoon salt
¾ cup finely chopped pecans

Preheat oven to 400 degrees.

Mix butter, sugar and vanilla thoroughly. Stir together flour and salt. Mix with butter mixture and nuts. Chill dough.

Heat oven to 400 degrees.

Roll dough in 1-inch balls. Place on an ungreased cookie sheet. Bake 10 to 12 minutes or until just set but not brown. While still warm, roll in powdered sugar.

Martha Whaley's Cinnamon Buns

1 pack of Fleischmann's rapid-rise yeast
¼ cup warm water
¼ cup sugar, divided
1 cup milk
¼ cup Crisco shortening
3½ cups plain flour (Gold Medal)
1 egg

Preheat oven to 375 degrees.

Add yeast to warm water and ½ teaspoon sugar. Let it rise.

Scald milk over low heat. Add the milk to the shortening and beat with an electric mixer until cool. Add 1½ cup flour to shortening mixture. Add 1 egg. Mix. When yeast is warm to the touch, add to the flour mixture and beat.

Add 1½ cups flour, or a bit more, until the mixture is not sticky and can be handled.

Put in a greased bowl. Cover with a towel. Put in a cold oven (to keep air off the dough) and let rise for 2 hours or until double in bulk.

Put dough on a floured board. Roll it out. Coat with filling mix (see below). Roll it up. Cut in 2-inch slices. Place in a cake pan. Recipe will fill two 9-inch cake pans. Bake at 375 degrees for 10 to 12 minutes or until golden brown. When cool, drizzle with icing (see below).

<u>FILLING:</u>
1 cup brown sugar
2 tablespoons cinnamon
1 cup Craisins or raisins
1 cup pecans (optional)

<u>ICING:</u>
Softened butter
Powdered sugar
A little milk

Martha Whaley's All-Bran Muffins

Yield: 6 full-size muffins

½ cup milk
¾ cup All-Bran cereal
½ cup sugar
2 cups self-rising flour (Gold Medal)
1 egg
2 tablespoons vegetable oil
1 heaping tablespoon sour cream

Preheat oven to 375 degrees.

Add milk to cereal and let it soften. Mix remaining ingredients together. Stir in cereal mixture.

Fill 6 cups in a muffin tin. Place on the middle rack of the oven. Bake for 10 minutes or until golden brown.

Martha Whaley's Creamed Corn

Fresh shucked corn, as many ears as desired
Butter
Salt

Preheat oven to 350 degrees.

Cut fresh corn off the cob. Cut roughly halfway through the kernels, and then scrape the rest off of the cob to get all the juice out.

Put in a skillet or pan with a heavy bottom.

Add butter and a little salt.

Cook on medium heat, stirring constantly, for about 10 minutes or until the mixture boils. If there is not enough juice in the corn, add a tad of water.

Martha Whaley's Green Beans

3 strips salt pork (some call it streaked meat or streak-of-fat/
* streak-of-lean)*
1–2 drops of oil
1 small onion or half a large onion, cut in 4 pieces
A mess of fresh green beans; any will do, but half-runners are the best
Water

Brown the meat with a drop or two of cooking oil and the onion. Put the beans in a large pot and add water so that it comes about halfway up the beans. Bring to a boil over high heat.

Reduce heat to just above a simmer, cover and cook for 1 to 1½ hours (until tender). Then take the lid off or tilt the lid. Turn the heat up to medium and cook until almost dry.

Stay with it; you don't want to scorch the beans.

Note: *This last cooking step is the secret to my beans. It's worth the extra time it takes.*

Martha Whaley's Macaroni and Cheese

1½ cups elbow macaroni
3 eggs
2 cups milk
2 heaping teaspoons flour
Pinch of salt
2 cups sharp cheddar cheese, shredded, divided

Preheat oven to 350 degrees.

Cook elbow macaroni according to package directions. Drain. Beat eggs, milk, flour and salt together in a bowl. Pour in macaroni. Add 1½ cups of cheese. Mix well.

Pour into a greased 1½-quart casserole dish. Top with remaining ½ cup cheese. Bake uncovered at 350 degrees for 25 minutes.

Martha Whaley's Chicken Gumbo

2 tablespoons bacon or chicken fat
1 medium onion, diced
2 stalks celery, sliced
⅓ cup green pepper, diced
1 quart chicken stock
2 cups canned tomatoes
1 teaspoon salt
⅛ teaspoon pepper
2 tablespoons chopped parsley
⅓ cup uncooked rice
1 cup okra, frozen
1–2 cups cooked chicken, diced

Heat fat in a Dutch oven or large pot over medium heat. Cook onion, celery and green pepper until soft but not brown. Add all the other ingredients, except the chicken.

Simmer for 40 minutes and then add the chicken. Heat until chicken is warmed through.

Note: *Martha's daughter prefers to omit the rice and serves the gumbo over cooked rice. Either way, it is delectable!*

Martha Whaley's Mouthwatering Biscuits

What really makes my biscuits special is the flour I use. It comes from Big Spring Mill, Inc., in Elliston, Virginia. It is simply called the Biscuit Flour. If you want to order some, see below. If not, White Lily flour works almost as well.

Yield: 9 3-inch biscuits

½ cup Crisco shortening
2 cups self-rising flour
Whole milk (start with ¼ cup)

Preheat oven to 375 degrees.

In a small bowl, cut the shortening into flour with a pastry blender until flour looks like coarse sand. Add milk slowly, just a little at a time, stirring with a metal spoon until the mixture forms a ball.

Sprinkle the counter or a cutting board with flour. Gently knead the ball of dough 4 or 5 times. Gently roll to about ½ inch thick. Dip a biscuit cutter in flour. Cut biscuits. Place on an ungreased pan with sides touching. Bake 10 to 12 minutes or until golden brown.

Note: *To order Big Spring Mill flour and cornmeal products, call* **540-268-2267** *during regular business hours. You must order at least twenty-five pounds. You can mix and match any products as long as the total weight is at least twenty-five pounds. Payments are made by credit card, either MasterCard or Visa. No COD orders. Products are shipped by UPS ground.*

And last but not least...

Dick Whaley's Hoecakes

2 cups self-rising cornmeal
½ cup green onions, chopped, tops included
1 egg
Milk
Oil or shortening

Mix cornmeal, onions and egg. Add just enough milk to make a soft dough.

Heat oil or shortening in a skillet, using enough to make the oil ½ inch deep. Dip a tablespoon of dough into the hot oil. Fry on both sides until brown. Serve piping hot.

Notes on Sources

CHAPTER 8: Martha's "facts" about the founding of the National Park were verified and supplemented using the nps.gov website.

CHAPTER 18: "What's New in Martha's Lifetime?" contains selected items taken from ideafinder.com and About.com/inventor.

CHAPTER 22: Scripture verses are from the King James Bible.

About the Author

Marie Maddox was born in Hickory, North Carolina, and attended Wake Forest University and the University of North Carolina–Chapel Hill. She received her bachelor's degree in English from the latter in 1971 and a master's degree from the University of Tennessee–Knoxville thirty-one years later.

Her teaching career began in 1991 in Gatlinburg, where she has taught Latin and English for twenty-three years except for a two-year leave of absence, in 2004–06, to teach in Istanbul, Turkey.

In 2012, Marie was commissioned to write and direct a play to celebrate the 100th anniversary of the Pi Beta Phi Elementary School (originally the Settlement School), where her own teaching career began.

Marie had wanted to write a book ever since she could remember, but she couldn't decide what kind of book to write or what to write about. So she never started. Then Martha came into her life in 2010, and she

knew. Happily, Martha was willing to let Marie try her hand at becoming an author.

Marie loves people (being with old friends or making new ones) and travel (by air, land or sea, at home or abroad). Her hobbies include reading and eating exciting food—prepared at home or discovered in a restaurant. Her canine pals, Thane (thirteen) and Claire (twelve), love her unconditionally and anxiously await her return from school every day.